COTSWOLD
PUBS AND BREWERIES

Cheers !

Tim Edgell

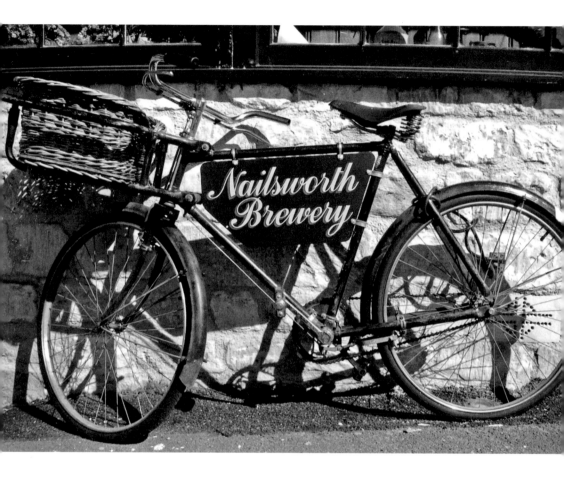

COTSWOLD
PUBS AND BREWERIES

TIM EDGELL

AMBERLEY

For Sarah, Hope, Isabella and Dad

In Memory of my dear Mum, Margaret

Charity Donation
For every book sold, the author will make a donation to cancer charities

Frontispiece: The finest malt, hops, yeast and water.
Naturally unspoilt. Do it the Cotswold Way.

The author collects Cotswold and Gloucestershire brewery memorabilia
and pub photographs. He can be contacted on 01453 835405 or
stroudbrewerytim@btinternet.com

First published 2010

Amberley Publishing Plc
Cirencester Road, Chalford,
Stroud, Gloucestershire, GL6 8PE

www.amberley-books.com

Copyright © Tim Edgell 2010

The right of Tim Edgell to be identified as the Author
of this work has been asserted in accordance with the
Copyrights, Designs and Patents Act 1988.

ISBN 978 1 84868 204 7

British Library Cataloguing in Publication Data.
A catalogue record for this book is available from the
British Library.

Typeset in 10pt on 12pt Sabon.
Typesetting and Origination by FONTHILLDESIGN.
Printed in the UK.

Contents

Acknowledgements

Special Thanks to: Howard Beard, Annie Blick, Ian Mackey, Ann Makemson, Keith Osborne, Geoff Sandles, John Saunders, Tony Wilton.

Many Thanks to: Andy (Badminton), The Athelstan Museum Malmesbury, Andrew Barton, Chris Bennett, James & Dorothy Bickmore, Terry & Douglas Cunningham, Eddie Cuss, Diana Dalton, Roger Davis, David Dines, Michael Dower, John Edgar, Jon Edgson, Hugh & Sue Elmes, English Heritage NMR, Mark Foot, Julian Fris, Mike Garner (Wizard Brewery), Andrew Gillett, Freda Gittos, Edward Godsell, Bryan Goodall, Mike Goodenough, Jennifer Greenhalgh, Howard Griffiths, Mike & Margaret Hawkes, Dave Hedges, Greg & Linda Huntley, Joy Jellings, Bob Kay, the ladies at Kodak Express (Stroud), Bill Kukstas, Jill & John Lanfear, Paul & Beryl Le Bars, Peter Legat, Richard Lilley, Mike Mills, Steve Montague-Davis, Russell Murfitt, Jeff Nash, The National Archives, Kew, Gerald Notley, Mr & Mrs Oakeshott, Neil Parkhouse, Amber Patrick, Robin Paul, Robin and Julian Pearce, Jason Perkins, Steve Pritchard, Kate Searle, Jeff Sechiari, Mattias Sjoberg, Jessica Stawell, Mark Steeds, Dr Jonathan Steel, Chris Stevens, John Strange, Andrew Swift, Dave Tate, Charles Taylor, David Taylor, Alec Thomas, Ian Thorn, Rich Tucker, Arthur Turbefield, Phil Warn, David Willatts, Kevan Witt and to everyone else who has given me help, information and encouragement.

Bibliography

Aldsworth 1000-2000 The History of a Cotswold Village, Jessica Stawell (New Clarion Press)
Bourton on the Water Tony Wray & David Stratford (Alan Sutton Publishing)
A Walk About Broadway, C. C. Houghton (Ian Allan)
The Inns of Burford, Raymond Moody (Hindsight of Burford)
The Chedworth Story, Howard J. Westlake (Trafford Publishing)
The Inns and Alehouses of Chipping Campden and Broad Campden, Celia Jones with Hilary Sinclair and Dorothy Brook (CADHAS)
Inns & Pubs of the Cotswolds, Mark Turner (Tempus Publishing Ltd)
Cotswold Villages, June R. Lewis (Hale)
The Donnington Way, Colin Handy (Reardon & Son)
A History of Eckington, Nils Wilkes
Fairford and Lechlade in Old Photographs, Edwin Cuss & Brian Rushby (Alan Sutton Publishing)
Gloucestershire Ale Trail 2008/09, Gloucestershire Craft Brewers (The History Press Ltd)
Best Inns & Pubs in The Cotswolds, Thames Valley & Chilterns, Joanne Brannigan, Gordon Dunkerley, Stephen Jones (Bracken Publishing)
Famous British Inns, Gloucestershire, David Conquest (Conquest Publishing & Print Ltd)
Gloucestershire Pubs and Breweries, Tim Edgell & Geoff Sandles (Tempus Publishing Ltd)
Kemble, Ewen and Poole Keynes, Three Villages by the Infant Thames, Christian Brann (Collectors Books Ltd)

A History of Malmesbury, Dr Bernulf Hodge (Friends of Malmesbury Abbey)
An Historical Guide to Malmesbury, Charles Vernon (Malmesbury Civic Trust)
Oxon Brews, The Story of Commercial Brewing in Oxfordshire, Mike Brown (Brewery History Society)
Pubs of Oxford & Oxfordshire, Paul Medley & John Dougill (Oxface Publications)
Snowshill, A Gloucestershire Village, Carolyn Mason (Thornhill Press)
Fertile Fields and small settlements A history of South Cerney and Cerney Wick, Michael Oakeshott (The South Cerney Trust)
Stow-on-the-Wold, Glimpses of the Past (Stow-on-the-Wold and District Civic Society)
Pubs of the Old Stroud Brewery, Wilfred Merrett (The Chalford Publishing Company Limited)
Wickwar Through The Ages
The Brewery at Woodchester Mansion, Brian Wollaston (Woodchester Mansion Trust Ltd)
The Wychwoods Album, Sue Jourdan & Sue Richards (Wychwoods Local History Society)
Century of British Brewers – Plus 1890-2004, Brewery History Society publication
The Quiet Pint A guide to pubs with no piped music, The Daily Telegraph (Aurum Press Ltd)
You Brew Good Ale A History of Small-Scale Brewing, Ian P Peaty (Sutton Publishing Ltd)
Good Beer Guide, various years , CAMRA publication
The Tippler, Gloucestershire CAMRA publication
Beer on Tap, North Oxfordshire CAMRA publication
Shakesbeer, Shakespeare country CAMRA publication
What's Brewing, CAMRA newspaper
Geoff Sandles website, www.gloucestershirepubs.co.uk

Introduction

I remember the good old days ... ten years ago when only seven pubs were closing nationally per week. Now it's that number EVERY DAY.

Against this backdrop the Cotswolds is relatively fortunate not to be losing too many pubs. That is not to say that the Bell & Castle at Horsley, the Twelve Bells in Cirencester or the Swan at Ascott-under-Wychwood will not be sorely missed.

It could be worse, much, much worse.

Bucking the trend in the economic downturn, Cotswold breweries are putting on a mighty show. Whether it is established brewers such as Hook Norton and Donnington or the resurgent microbreweries, Cotswold beers are still 'Best in the West'.

In recent Society of Independent Brewers (SIBA) National Awards, Severn Vale Brewing Co. won overall gold in 2008. There have been excellent results for the new Stroud Brewery and Cotswold Spring Brewery. Wickwar Brewery Co. won CAMRA Supreme Champion Winter Beer in 2008.

The Cotswolds, comprising parts of Gloucestershire, Oxfordshire, Wiltshire, Warwickshire and Worcestershire, is designated the largest Area of Outstanding National Beauty (AONB) in England. This quintessentially rural landscape of mellow stone villages and market towns was made rich hundreds of years ago by the golden fleeces of the Cotswold lion sheep.

The book includes areas north of the M4 and then mainly delineated by the AONB. The oolitic outlier of Bredon Hill and its villages is also featured. So apologies to the Vine Tree at Norton, the Crawley Inn and the Plough at Stretton-on-Fosse which are not included.

As in the author's other book for Amberley Publishing, *Dorset Pubs & Breweries*, the chapters are organised by area. Each chapter moves from east to west in sweeps before moving northwards to start another. It is a bit like an old typewriter in reverse.

Centuries ago, Cotswold ale was largely made in the home, on farms or by monks. Then inns began brewing. In the nineteenth century, most Cotswold market towns, such as Malmesbury, Dursley and Chipping Norton, had 'common' breweries that bought the inns and further centralised production. In turn, these breweries were acquired by regionals such as the old Stroud Brewery or Hunt Edmunds – mostly in the twentieth century. Next, the nationals rose to prominence.

Enter the microbreweries. Breweries such as Wickwar, Uley and Goffs have experienced tremendous success. This paved the way for younger 'craft' breweries such as the new Nailsworth Brewery, Battledown, North Cotswold and Patriot. Eight of these newer arrivals have formed an association, 'The Gloucestershire Craft Brewers' to further promote their ales. The Costwolds even has two specialised lager craft brewers, such is the demand for local beer.

Partly as a result of the Beer Orders of 1990 some nationals such as Whitbread stopped brewing and sold their estates to Pub Companies, or Pubcos, run by accountants who demanded ever increasing discounts. Many Pubcos have run into trouble by borrowing against high property prices.

Luckily, the Cotswolds is a haven for traditional inns, of which an essential requirement is real ale. The number of pubs in the Cotswolds has declined over the last century in line with the country as a whole, but thankfully the rate of decline has slowed.

The reduction has not been taken lying down at any time. Indeed in 1908, there was a near riot in Stroud as a result of a meeting to discuss the introduction of a Liberal Bill to reduce the number of public drinking houses.

CAMRA has fought pub closures and the issue of restrictive covenants. The smoking ban has been anticipated with designated smoking areas, infra-red heaters and large parasols. CAMRA's 'Locale' scheme informs the public which pubs sell locally produced ales.

There has also been a shift in the type of customer. Rural locals, once the preserve of farm workers, now have to attract the middle classes to survive. Gastro-pubs, or the recently coined 'Country Dining Pubs', such as the Chequers at Churchill, the Feathered Nest at Nether Westcote and the Howard Arms at Ilmington, have proliferated in the Cotswolds. Without this development, a large proportion of rural pubs would have closed. Most set aside an area for local drinkers and, as Hilaire Beloc once wrote, 'when you have lost your inns, drown your empty selves, you have seen the last of England'.

All types of establishment are represented in the book.

The author has developed a passion for Cotswold pubs over twenty-five years and has visited most. Unfortunately it is beyond a book like this to feature them all. So more apologies – to the Royal Oak at Woodchester, the Bakers Arms at Broad Campden and the Gardeners Arms at Alderton. There are many more too.

The lesson of history is that nothing lasts forever. Please visit a Cotswold pub and buy a local beer. Let's rewrite the lesson.

South Cotswolds

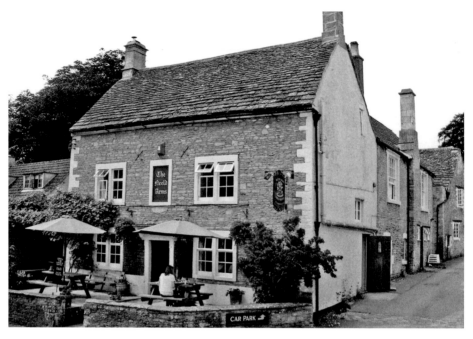

Known long ago as the Red Lion, the seventeenth-century Neeld Arms in Grittleton closed in the early 1990s. Locals were very thankful when it re-opened, for the Neeld Arms is still a pub at the heart of the community. Beer quality is excellent and the pub deserves its inclusion in the CAMRA *Good Beer Guide*.

The Duke of Beaufort built the Portcullis Hotel to house guests who arrived by train. Located nearer Acton Turville, the date stone shows 1903, which ties in with the downgrading of the Portcullis Inn (see next). The hotel became a private house mid-century. Two old ladies who lived there used to throw handfuls of threepenny bits to children from the balcony.

In Badminton itself, to the left of the Estate gates is Badminton Village Club. This was the old Portcullis Inn and Brewery. The brewery supplied substantial amounts of ale to the Estate but closed in 1902 when Joseph Davies was innkeeper/brewer. At nearby Tormarton there is another Portcullis Inn which is still an excellent, traditional local ale pub.

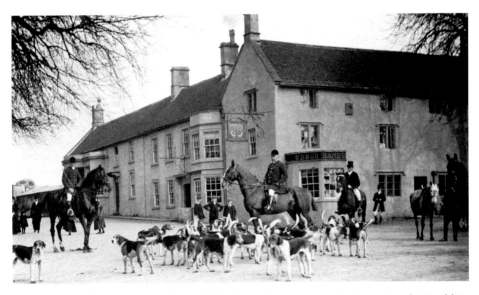

Modestly standing by crossroads in Old Sodbury for centuries, the Cross Hands Hotel hit the headlines on 13 December 1981. In blizzard conditions the Queen made an emergency stop at the hotel. Appearing in gumboots and a headscarf, she took shelter in room 16 and the manager's accommodation. Seven hours later, snowdrifts cleared, the royal party left for Windsor.

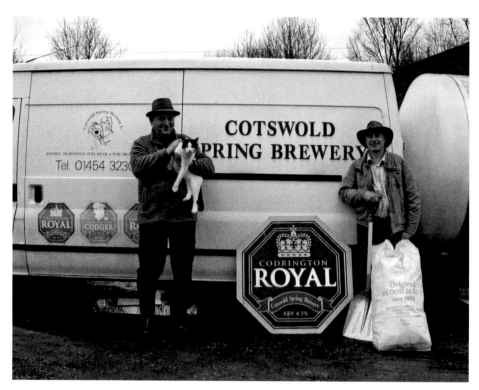

At Cotswold Spring Brewery near Codrington, brewer Nik Milo holds the resident pest controller – Smuggles the cat. Steve Harker (ex Home County Brewery, Wickwar), collects the spent malt for his farm. Nik (aka The Bear) has been at Cotswold Spring Brewery since it was set up by owners John Warlock and Warren Bryant in 2005.

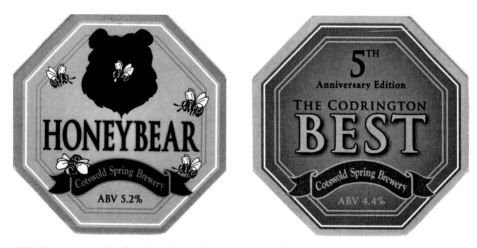

CSB Mystery was the first beer brewed and immediately won an award at the Avon Vale Beer Festival. Since then Gloucestershire Glory, Old Sodbury Mild and Honeybear have scooped more awards. Honeybear won silver at the SIBA National Competition in 2010. The excellent ales and distinctive signage have helped the brewery develop a strong sense of character.

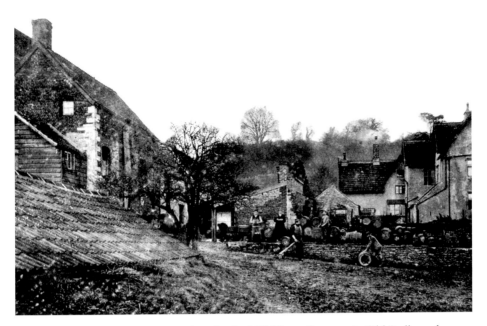

In July 1884 James Mason Perrett bought the Hill House Brewery in Old Sodbury from John Hatherell, whose family had brewed there for several decades. Under James Perrett the brewery owned six pubs including the Hartley Arms on the premises, and rented another sixteen including the Cross Hands Hotel. The brewing equipment was sold off in September 1922.

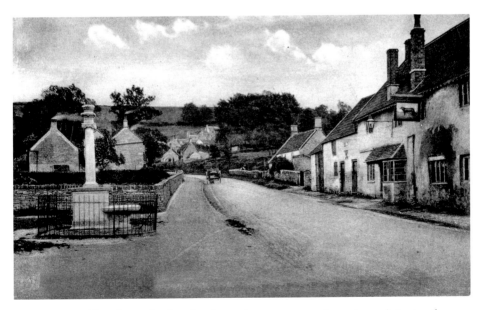

Roadside in Old Sodbury, the Dog Inn is much smarter now than pictured. An inn for nearly two hundred years, a brewhouse was mentioned twice when the pub was sold in the nineteenth century. Afterwards it was owned by James Mason Perrett, and now is a welcoming, family-run traditional pub with its own badged ale, Dogs Best.

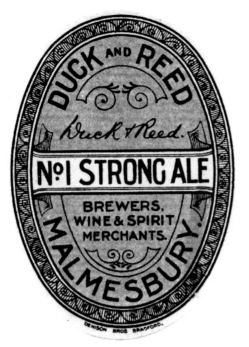

Esau Duck began brewing in the 1870s behind 32 Cross Hayes, Malmesbury, selling beer to navvies. Around 1892 he formed a partnership with son-in-law Thomas Reed to buy Cross Hayes Malthouse. The Reeds moved away in 1911 and the brewery traded as Duck & Co. Arthur Monte Duck inherited the business but sold to the old Stroud Brewery in 1920 with twenty two pubs.

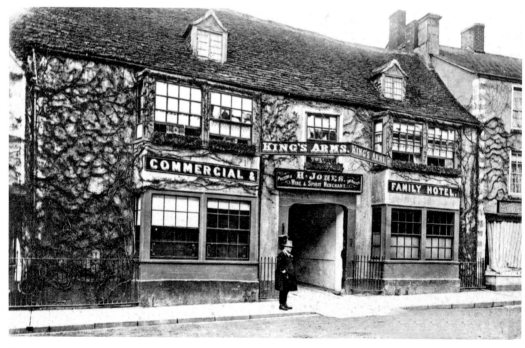

Over a century ago, Harry Jones was proprietor of the Kings Arms in Malmesbury High Street. Resplendent in bottle green coat and breeches, red waistcoat and top hat, he accommodated the great and the good. Letters addressed to a drawing of a top hat, Wiltshire, would find him. 'The last of the old Hoteliers', he died in August 1911.

By the Avon at Malmesbury, stood the maltings (pictured) of Charles Richard Luce, with his Mill Brewery to the left. The old Abbey Brewery (still standing behind Market Cross) was also run by Luce. The family started brewing in 1821 but the business, with forty two pubs, was sold to the old Stroud Brewery in 1912 for £35,000.

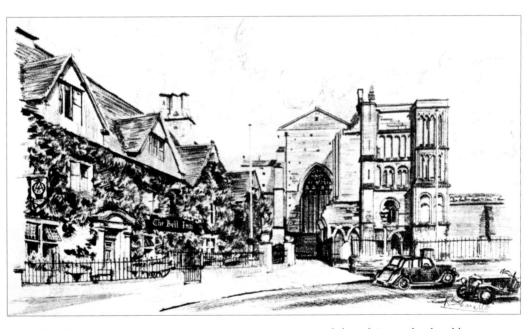

The Old Bell Hotel began entertaining visitors in 1220 and thus claims to be the oldest purpose built hotel in England. Joseph Moore enlarged the hotel over a century ago and was listed as a brewer there. Other hostelries in Malmesbury worth visiting include the Three Cups in The Triangle and the CAMRA *Good Beer Guide* listed Whole Hog in Market Cross.

One of only two pubs called the Cat & Custard Pot in England, this rural village gem is in Shipton Moyne. A beerhouse from the eighteenth century with a stores and bakery on the left, it had an off-sales licence only until 1924. Bought then by the old Stroud Brewery for £700, it changed to an on-licence and adopted its curious name.

The Hare & Hounds Hotel is a thwack away from the Beaufort Polo Club. The older part was completed in the Renaissance style by Robert Holford in 1854. He had previously founded Westonbirt Arboretum, demolished the original Hare & Hounds and moved the village. Now the hotel includes Jack Hare's Bar where ales, including their own badged Jack Hare's, are sold.

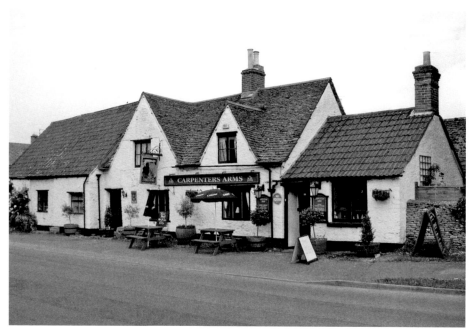

Eighty years ago Sherston had seven pubs and hotels. Today only two survive – the
Carpenters Arms (pictured) and the Rattlebones Inn (country dining pub). During the 1960s
the Carpenters Arms was known as a cider and ale house, with few women among the
drinkers. It is still a super traditional multi-roomed pub but wholly welcoming to everyone.

When the Bell Inn closed several decades ago, the Old Royal Ship was the only pub left
in Luckington. What a cracker it is too. Extended to the left, it deftly strikes a balance
between local drinkers and restaurant clientele. Previously an outpost of the old Luce
Brewery, local ales are still available to all, especially when the Beaufort Hunt visits.

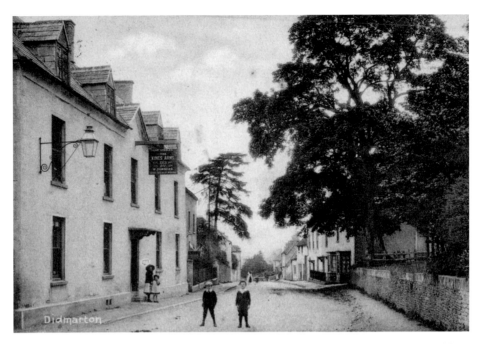

The Kings Arms at Didmarton belonged to Cooks Brewery of Tetbury when these children were playing outside the coaching inn. The Edwardian villagers would be glad that excellent local ales are still consumed here, and that Rook Pie was served until recently. Previous landlords Nigel and Jane Worrall resurrected the annual Rook Supper. Alas, the feast is no more.

Firstly named the Crown Inn, then Beaufort Arms Inn, the Bodkin House Hotel in Petty France was reinstated as a hotel in the 1970s. Its stables across the A46 are now private houses. Jane Austen stayed here and mentioned the house in Northanger Abbey. Currently the hotel is a wonderful place to visit with a comfortable oak-panelled bar serving local ales.

Outside the Beaufort Arms at Hawkesbury Upton, the author (left) congratulates landlord Mark Steeds on another award for the pub. When asked why the pub is so popular Mark replied 'Definitely the landlord!' Mark provides excellent beer and food, a traditional welcome, a stunning collection of brewery artefacts and is actively involved in local issues.

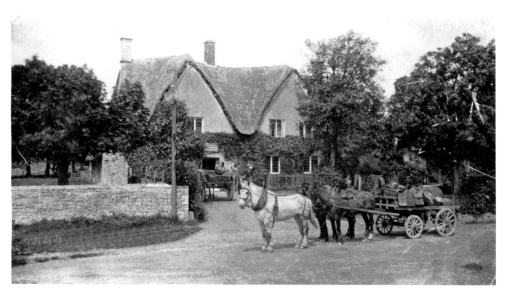

A brightly painted Arnold Perrett of Wickwar dray stands outside the Portcullis Inn at Hillesley. John Arnold of Wickwar and Perretts of Old Sodbury also delivered to Hillesley. The Portcullis is closed but next door the Fleece Inn is still open. A century ago owned by Witchells, then Warns of Tetbury, the Fleece is now an endangered village pub.

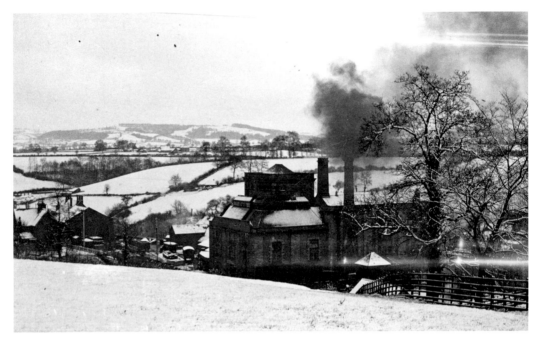

The Wickwar brewery of Arnold & Co transferred to Station Road in the mid nineteenth century. With Thomas Halsey in charge, Henry Perrett's Bournstream Brewery was acquired in 1887 and Arnold, Perrett & Co was formed. It closed in 1927. In the High Street, through the Bell Entry, John Arnold had a separate brewery. The business traded from 1861 to 1930.

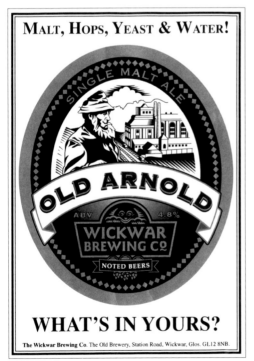

Established in 1990 by Ray Penny and Brian Rides, the Wickwar Brewery has been a real success story. Moving from the old cooperage into the former Arnold Perrett brewery over the road in 2004, the beers have gone from strength to strength. Station Porter was voted CAMRA Supreme Champion Winter Beer in 2008 and BOB has become a national brand.

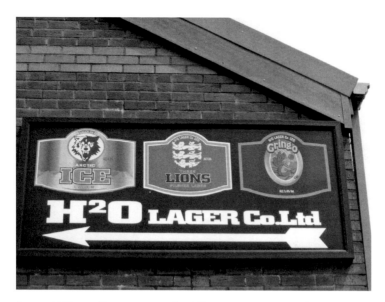

In 2008 Warren Bryant set up the H²O Lager Co. at Wickwar, brewing 'no ordinary lager' with German-made equipment. Gringo was first – a lager with tequila and lime. The latest, OMG, comes bottled in six different flavours. Previously the premises housed Steve Harker's Home County Brewery. Beers such as Wichen and Golden Brown are sadly no longer brewed.

The Buthay is the last pub left in Wickwar. In the past called the New Inn, it is comfortable, roomy and has character. It should be a thriving community pub but is up for sale. The other High Street venue is the Social Club. Founded by ninety-six village men in 1936, women were only allowed to join in 1969.

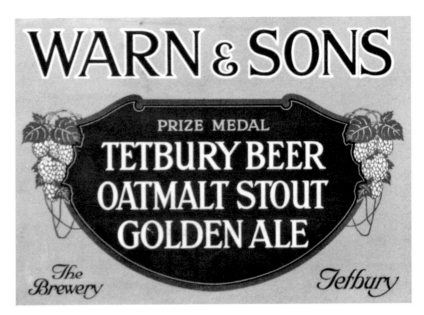

For most of the nineteenth century Warns Barton Brewery adjoined Witchells Dolphin Brewery in Church Street, Tetbury. Their business was largely conducted from off-licences by the breweries. The familes inter-married and in 1903 Warns acquired Witchells, and in turn was taken over by the old Stroud Brewery in 1931. Warns Cotswold Ale (rich & malty) is now a distant memory.

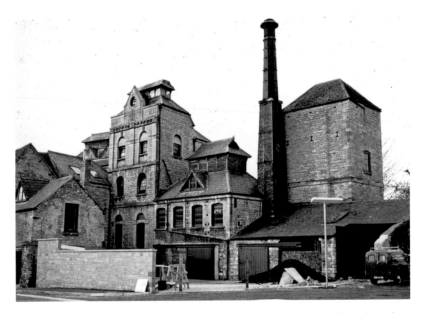

Cooks Tetbury Brewery was altogether a much larger concern. When bought by the old Stroud Brewery in 1913, it had thirty-three tied houses including the Crown Inn and Greyhound in town. According to local legend, the inscription 'Established 1800' on the tower was added in 1901 when the brewery was revamped, as the actual date was unknown.

An inn from at least the eighteenth century, the Crown is now at the start/finish line for the annual Tetbury Woolsack Races. Carrying sacks weighing 60 lbs (men) or 35 lbs (women), competitors race down and up Gumstool Hill. At the bottom of the hill, the welcoming Royal Oak still provides excellent refreshment for spectators and competitors alike.

On 15 March 1919, to the reverse of this postcard of the Ormonds Head, landlord Harry Miller urgently requests from the Cheltenham Original Brewery 'as much beer, spirits, Bass and Guinness that are available'. Thankfully there are no such shortages in Tetbury today. A varied selection of ales is available at The Ormond, Snooty Fox, and Priory Inn.

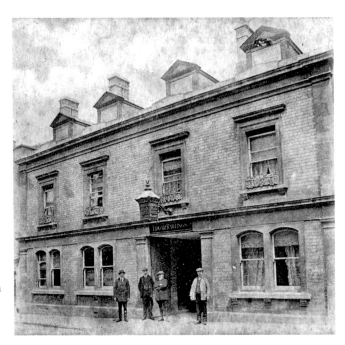

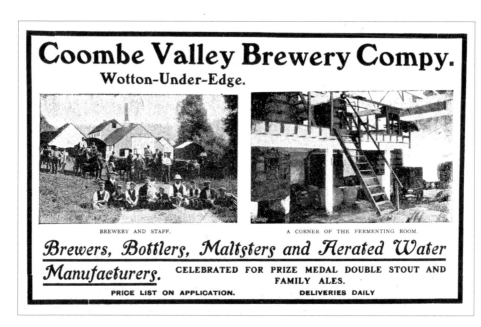

Coombe Valley Brewery Compy.
Wotton-Under-Edge.

BREWERY AND STAFF. A CORNER OF THE FERMENTING ROOM.

Brewers, Bottlers, Maltsters and Aerated Water Manufacturers. CELEBRATED FOR PRIZE MEDAL DOUBLE STOUT AND FAMILY ALES.

PRICE LIST ON APPLICATION. DELIVERIES DAILY

By Coombe Lakes near Wotton-under-Edge, the Coombe Valley Brewery was established in the late nineteenth century by Arthur Guinness. Carried on next by Major Annersley, the brewery relied on the free trade for its sales. At the time of the advert (1904) some twenty staff were employed, but sadly trade declined and the brewery closed by 1914.

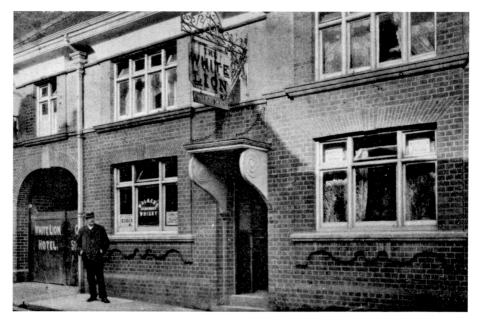

In the 1940s, Tom Scadding ran the White Lion Hotel in Wotton-under-Edge. He was a jovial landlord and started a club. Among the rules were 'No member should give up beer for the sake of work' and 'All glasses to be tilted towards the mouth and not the ear'. Were the White Lion's Cheltenham Ales really that strong?

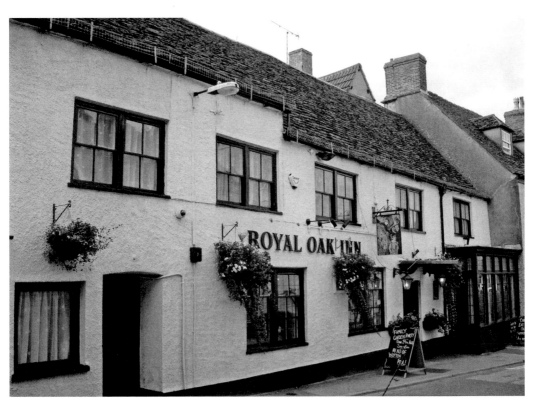

Just over a century ago, Wotton-under-Edge had about twenty pubs and hotels. Now there are only five – the Royal Oak, Swan Hotel, Star, White Lion and Falcon Inn. Fortunately every pub serves different ales. Selections from local breweries are available at the Falcon, including their own badged Monument Bitter and Cider, the Star, Swan and Royal Oak

BOURNSTREAM BREWERY, WOTTON-UNDER-EDGE.

H. & A. PERRETT,

STRONG BEER, PALE ALE, AND PORTER BREWERS,

MALTSTERS AND HOP MERCHANTS.

DEALERS IN FOREIGN AND BRITISH SPIRITS.

THE TRADE SUPPLIED DIRECT FROM BOND.

ALL ORDERS SHOULD BE PARTICULARLY ADDRESSED TO

BOURNSTREAM BREWERY, WOTTON-UNDER-EDGE,

[8] WHICH WILL HAVE IMMEDIATE ATTENTION.

To the west of Wotton-under-Edge, the Bournstream Brewery was established in 1846 by David Perrett, a 'common brewer' from Nibley. Upon his death in 1869, ownership passed to his sons Henry and Absolom. Absolom sold his share to Henry in 1887 and soon after, Henry sold the business to Arnold & Co of Wickwar.

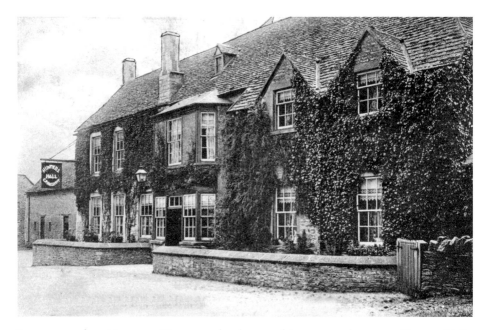

In an exposed position near Kingscote, the characterful seventeenth-century Hunters Hall still welcomes villagers and travellers. To the rear there is a marvellous old tap room. Sixty years ago beside the pub, Kingscote's married men and single men played each other at football. When the number of single men declined, they played darts instead.

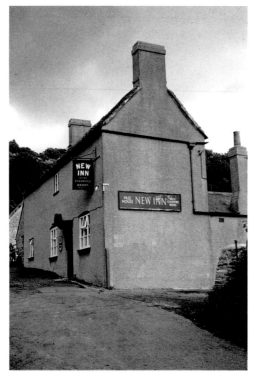

The New Inn at Waterley Bottom in 1960s West Country Ales days. Still a wonderful pub, a Ball Throwing Challenge takes place annually from the nearby New Inn at Woodmancote through the woods to Waterley Bottom. Originally using metal balls, health and safety intervened and now water filled lawn bowls are thrown. The team with the fewest throws wins the 'Whitbread Cup'.

In 1811 Cotswold House (centre left) was known as the Berkeley Arms Inn and owned by Adam Perrett. The extension (left) was a malthouse and the building (right) was the North Nibley Brewery. By 1836 William Millard Hooper owned the brewery and an 1867 directory advertises David Perrett Junior there. It seems the brewery went out of use soon after.

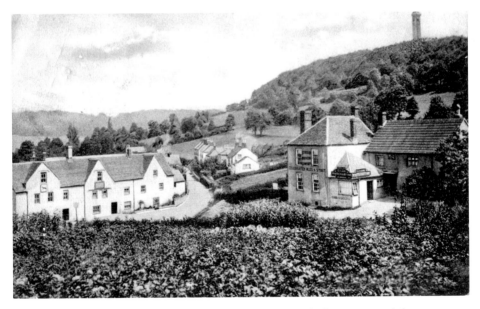

Posted in 1915, this postcard of North Nibley shows the Black Horse Inn (left – an Arnold Perrett pub) and White Hart (right – an old Stroud Brewery Pub). The White Hart (closed mid twentieth century) was originally the first inn on the medieval route from Berkeley Castle to London. Today the Black Horse is a country dining pub still serving Wickwar ale.

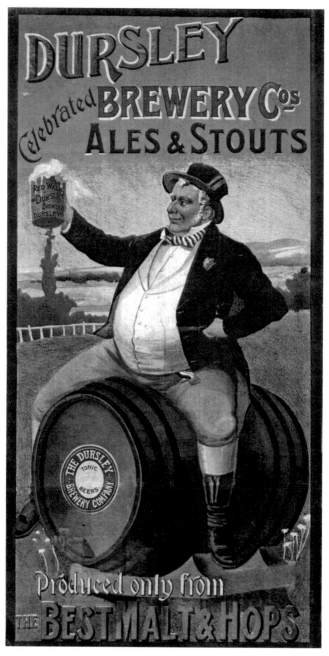

Brewing in Dursley developed in the nineteenth century on four main sites. On the corner of Boulton Lane and Silver Street was the Dursley Steam Brewery. Established around 1850, it was bankrupt in 1906. On the corner of Water Street and Bull Pitch was a brewery run by various partnerships involving the Bloxsome family. It was sold in 1885. In Long Street on the site of the *Gazette* offices was the Old Brewery. It started in 1823 and was sold around 1870. At Redwalk (near Rednock) were the premises of the Dursley Brewery Company which operated during the second half of the nineteenth century. (The National Archives, ref COPY 1).

Far left at the top of Bull Pitch was the Bull Inn, then advertising Elvy's Ales (Dursley Steam Brewery). In 1907 the Bull was among twenty-one pubs bought by Godsells of Stroud after Elvy's bankruptcy. Further along the terrace, mid-nineteenth century, the Organ family with various partners operated the small Woodmancote Brewery, although their main business was malting.

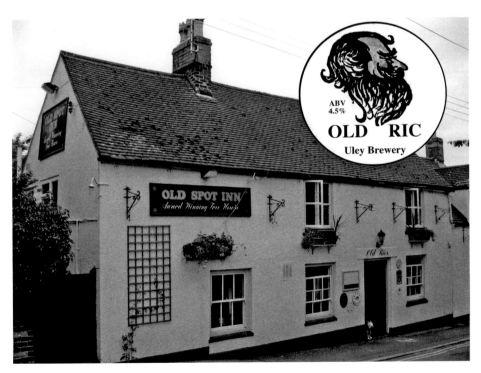

The superb Old Spot in Dursley – CAMRA National Pub of the Year 2007. Uley Brewery named a beer after the previous legendary landlord Ric Sainty who retired in 2001. Since then, Steve and Belinda Herbert have continued the award-winning tradition. Sadly 'Old Ric' died in 2008. In March 2010 a blue plaque was unveiled at the pub in his memory.

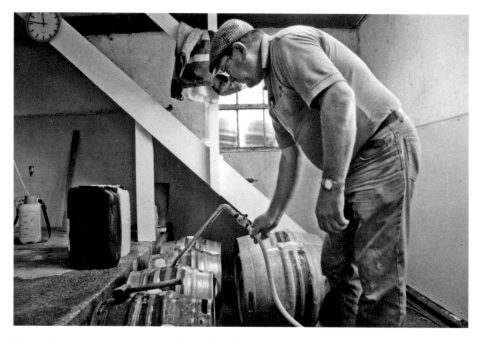

The period 2005-2007 was good news for the Cotswolds as six small breweries were set up. All are flourishing. Steve McDonald started the Severn Vale Brewing Co. in an old milking parlour at Cam in 2005. A founder member of the Gloucestershire Craft Brewers, he has been at the forefront of the recent resurgence of Cotswold microbreweries. (Photograph by Charles Taylor).

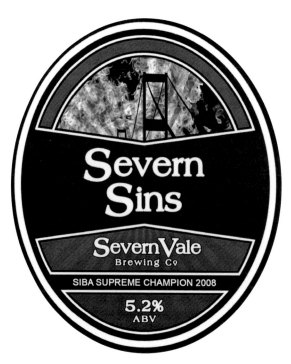

Steve McDonald's first beer Vale Ale quickly established his reputation for quality. This was further enhanced when Severn Sins was crowned SIBA Supreme National Champion 2008. Other ales have also been well received. Dursley Steam Bitter is a SIBA award winner, Session is a regular at the Old Spot in Dursley and Monumentale is an award-winning dark beer.

TWO

Stroud Area
Cotswolds

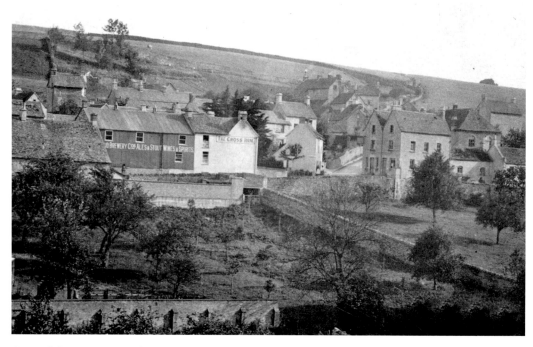

Centre left at Avening is the Cross Inn, a great community local with the village stores recently reopened behind the pub. Opposite, the double gabled building was the Sawyers Arms. During the Second World War a lorry carrying tinned cream crashed into the building (by then no longer a pub). For years the cupboards of Avening were well stocked with Nestles cream.

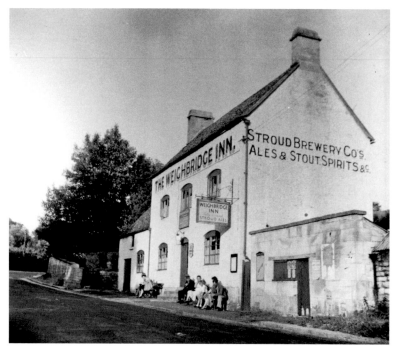

The award-winning Weighbridge Inn on the Avening to Nailsworth road has the very best reputation for its delicious two-in-one pies and regularly rotating guest ales from local breweries. Over a century ago the Weighbridge was owned by Arthur Twisden Playne whose relative George Playne owned the nearby Forwood Brewery and supplied the inn with ale.

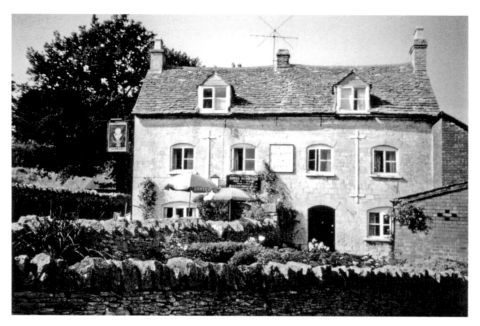

South of Minchinhampton at 'The Point' in Forwood, the Kings Head Inn is fondly remembered. For the latter half of the nineteenth century the inn was the tap house for George Playne's Forwood Brewery, which stood a short distance up the lane. The old Stroud Brewery acquired Forwood Brewery in 1897. Unfortunately the Kings Head closed in the late 1960s.

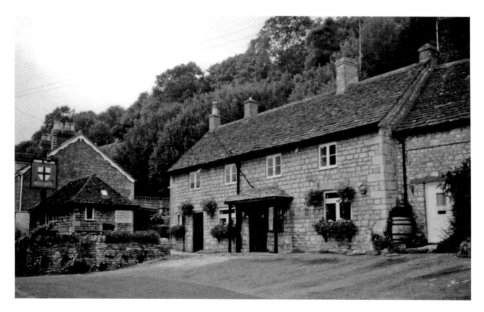

Known as 'Nailsworth's Best Kept Secret', the George Inn at Newmarket is half a mile west of Nailsworth. A traditional pub with no gaming machines or jukebox, the George has been run by Bob Pike and David De Sousa for over twenty years. It is a CAMRA *Good Beer Guide* regular with a couple of well-kept Uley beers among the four ales served.

Nailsworth Brewery Co.,
Limited,
NAILSWORTH, Glos.

BREWERS OF
High-class Pale Ales
and Celebrated Stout.

Founded around 1800 by the Clissold family, the old Nailsworth Brewery amalgamated with the Cheltenham Original Brewery in 1908. At the time it had around sixty tied houses. Alfred Barnard, the noted Victorian brewery reviewer visited in 1885 and praised the quality of the Stout. The local water particularly suited this type of beer – as it does today.

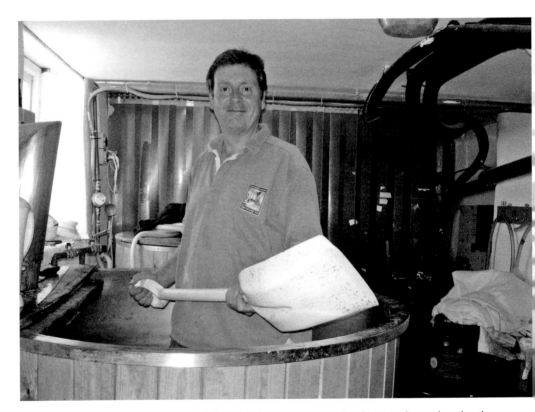

After a gap of ninety six years, the Nailsworth Brewery rose again, this time located under the Village Inn. A venture between Jon Kemp (pictured) and Oisin Hawes, the new brewery has its own well and has achieved deserved success. In 2009 Old Rocky was Champion Beer of Gloucestershire and Alestock was class winner in the SIBA National Competition.

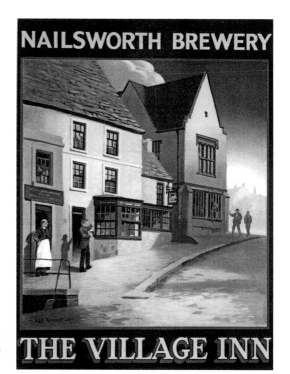

Oisin Hawes achieved a stunning renovation of the Village Inn. Modelled on the layout of an Irish pub, the Village is multi-roomed on different levels. The result is a hostelry rated in the top twelve in the country. Not only are up to ten real ales dispensed, but the pub now has TWO BREWERIES.

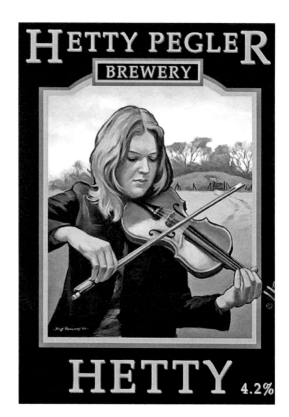

The brewery that puts the micro into microbrewery. With the Nailsworth Brewery going at full-tilt, Oisin Hawes hatched a plan for a second brewery at the Village Inn to increase the number of ales produced on the premises. Named after a local landmark, Hetty Pegler Brewery's beers such as Indian Summer and Admirals Ale have been well received at the pub.

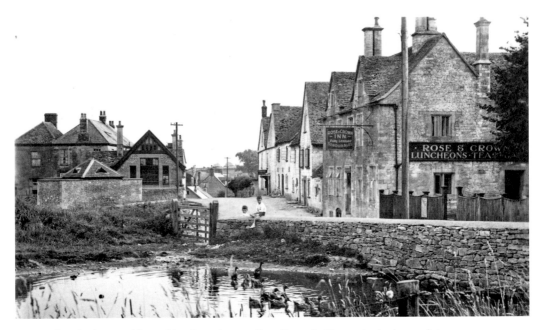

A three hundred year old coaching inn, the excellent Rose & Crown is the last pub in Nympsfield. The village had five pubs a century or more ago as it was on a busy coaching route. Now Nympsfield is a quiet hamlet, the Rose & Crown should be appreciated. To entice customers, up to four local ales are available and there is a wonderful vaulted restaurant.

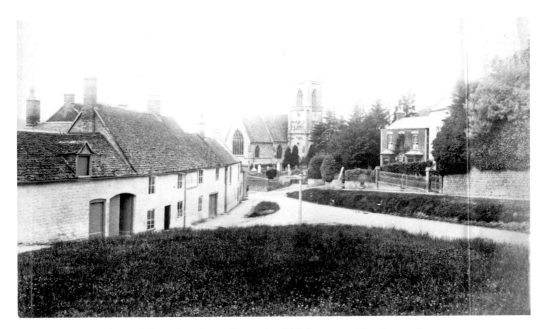

Once again the only inn left trading in a village, the Old Crown at Uley has undergone a recent transformation and rightly is hugely popular again. Serving a rotating selection of up to six ales, including two from the cracking Uley Brewery just down the road, the Crown has the irresistible combination of a warm welcome, foaming beer and great pub grub.

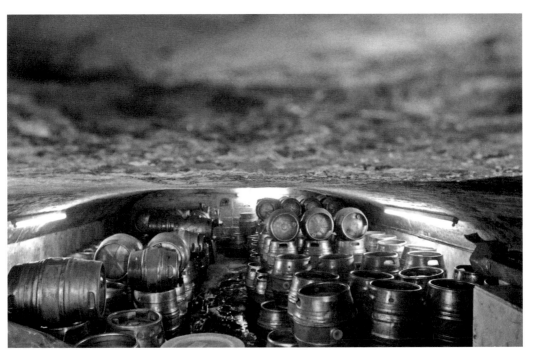

Samuel Price established a brewery at Uley in 1833. It closed some seventy years later. In 1985 Chas Wright recommenced brewing using the same premises and low arched cellar (pictured). Maintaining the same principles of using Cotswold spring water, malt and English hops, Uley now supplies dozens of Cotswolds pubs with their multi award-winning ales. (Photograph by Charles Taylor).

Congratulations to Uley Brewery on twenty-five years of brewing marvellous real ale, and for defending Cotswold beers. In 1997, the Ipswich brewery Tolly Cobbold began supplying 'Cotswold's PA'. Chas saw red. Retaliation was the only course of action. So Uley rebadged its bitter and launched it into East Anglia. The name of the beer – Suffolk Mountain Ale.

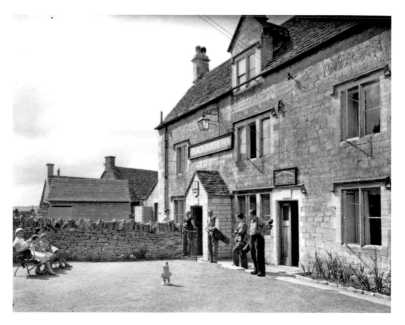

On the edge of Minchinhampton Common, the views from the Black Horse at Amberley are stunning. Watching the sun set over hills and valleys with a pint of excellent Stroud Brewery Budding or Tom Long – heaven. Nearby, the Bear Hotel welcomes guests in its traditional bar by the croquet lawn with up to three local ales.

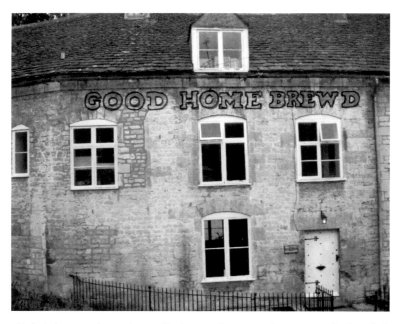

Precious little is known about the small nineteenth-century brewery in the lane behind the Old Fleece Inn at Rooksmoor. The lettering has been outlined as it is now very faint. Perhaps the Victorian sign painter imbibed too much Home Brew and miscalculated the spacing of the letters. Happily the popular Old Fleece on the A46 continues to thrive.

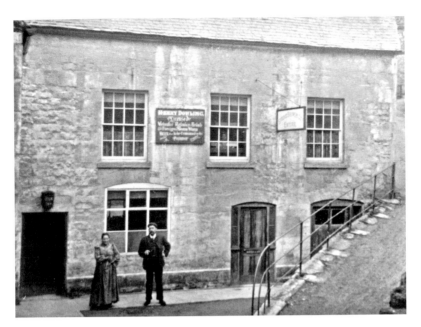

A CAMRA *Good Beer Guide* regular, the Ram Inn at South Woodchester has been highly regarded for its ales probably since Mr and Mrs Dowling (pictured) ran the pub. The arrival of the new Nailsworth and Stroud Breweries has further enhanced its reputation and ale selection. The lovely view today is more lush woodland than sheep grazed wold.

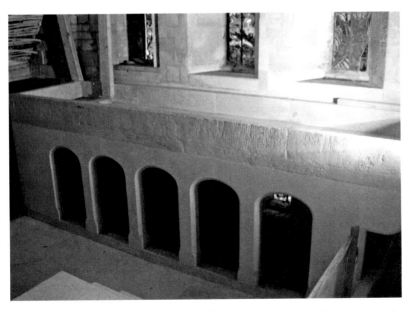

Perhaps the spookiest brewery in the Cotswolds, if not the land, no beer was ever brewed at Woodchester Mansion. Construction of the Victorian gothic masterpiece suddenly ended. The brewery, with its outstanding cut stone cooling tank supports (pictured) has lain idle for more than a century and is now home to a colony of bats. The brewery opens to visitors every year in October.

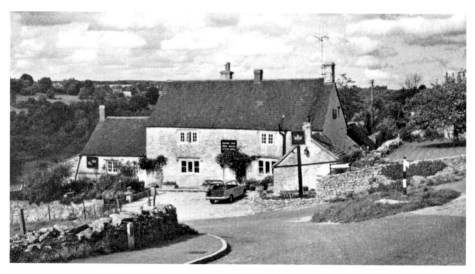

The Crown Inn at Frampton Mansell is a dream of a pub. Recorded under the 1737 Licensing Act, it was a cider house for at least a century before then. Now the interior stone walls have been darkened by the ages and it is all the more atmospheric by candlelight. A changing range of thirst quenching, mainly local, ales is served. Perfect.

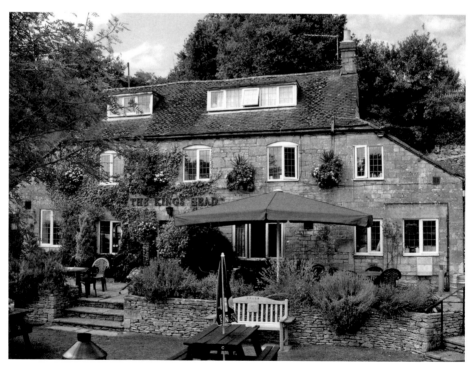

Wind your way in through the country lanes and relax when you arrive at the splendid Kings Head at France Lynch. Mike and Pat Duff rescued the pub (which had closed) in 1997. Their warm welcome, excellent ales and summer music festival helped the Kings Head win the Pub of the Year 2010 award in the local newspaper *Stroud Life*.

The Anchor Inn at Chalford had closed a few years before this 1911 photograph. It had been one of twelve pubs along the valley bottom locally, from the Valley Inn to the Queens Head at St Marys. This number included an unlicenced home brew house by Tankards Spring. One of several in the village, they were known as 'Tom Tiddlys'.

Today, the New Red Lion Inn is the only survivor of the twelve valley bottom pubs in Chalford. Photographed here in the 1880s with its gable facing east advertising Nailsworth Ales & Stout, it too nearly did not survive. Having burnt down soon after the photograph was taken, it was fortunately rebuilt in its current form with gables north and south.

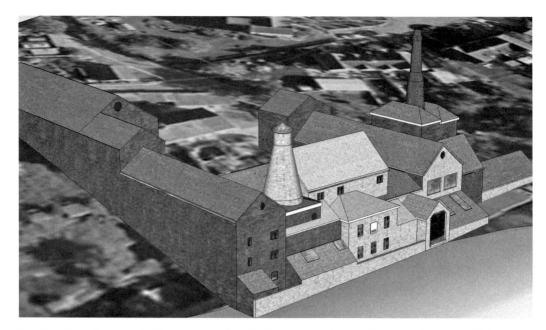

Smith & Sons Brimscombe Brewery was founded in the late nineteenth century but was sold in 1919 and later demolished. Tony Wilton of Stroud Design Ltd has created a 3-D model of the brewery (using Google Sketchup Professional) from maps and photographs dated around 1910. Views from the South and South West were available. Further views from the North and South are sought. This link will enable you to download and view the model in 'Google Earth': www.strouddesign.ltd.uk/190101-BrimscombeBrewery.kmz

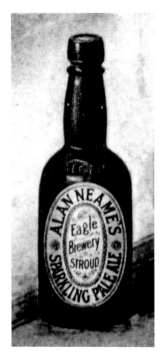

Past the Brimscombe Brewery and the Tanner family's Thrupp Brewery, Alan Neame ran the small Eagle Brewery from behind the British Oak pub at Bowbridge. He was a great self-publicist and realised the value of advertising, matching the much larger Stroud Brewery in the local newspapers. Sadly the Eagle Brewery only lasted from 1892 to 1897.

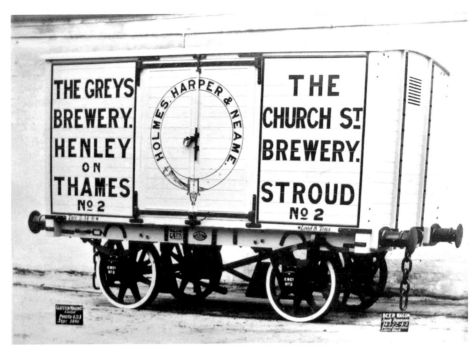

Alan Neame had been part of Holmes, Harper & Neame who operated the Church Street Brewery in Stroud. Other brewers such as Mr C. Jones and Charles James had come and gone from the same premises earlier in the nineteenth century. The brewery was offered for sale in January 1892 and their nineteen pubs were sold to the old Nailsworth Brewery.

Established in 1850, Godsell & Sons Salmons Springs Brewery was the main competition for the old Stroud Brewery. Other local breweries such as Carpenters, Cordwells and Guildfords struggled for outlets. However, despite having the very best reputation for the quality of their beers, by 1928 the Godsell family sought to sell up to the Stroud Brewery with around 100 pubs.

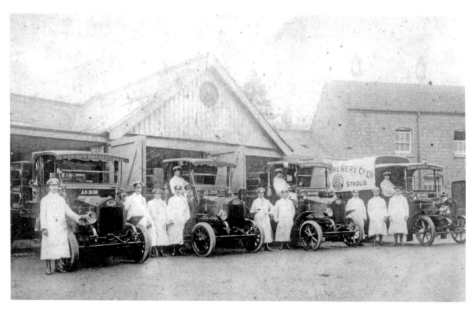

A Whitbread publication in 1960 celebrated '200 Years of Brewing in the West Country'. Colonel Whitbread confirmed that the Stroud Brewery had merged with the Cheltenham & Hereford Brewery under West Country Brewery Holdings Limited. He wished the venture a 'long life'. By 1967 brewing had ceased in Stroud. The offices and brewery, which dominated Rowcroft, were demolished in 1970.

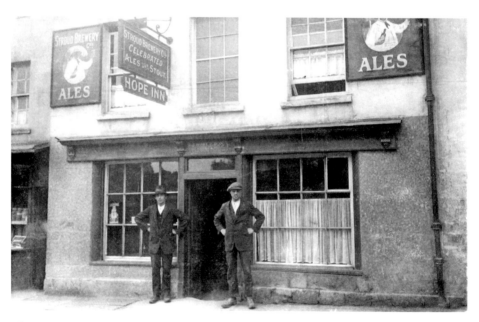

There is no doubt the Hope Inn was an old Stroud Brewery pub. Located near the brewery in Cainscross Road (and now demolished), the Hope Inn sold Stroud beers such as XX Mild and Cotswold Ale. It is said beer from the old Stroud Brewery tasted like the Uley ales of today or Flowers Original when it was brewed in Cheltenham.

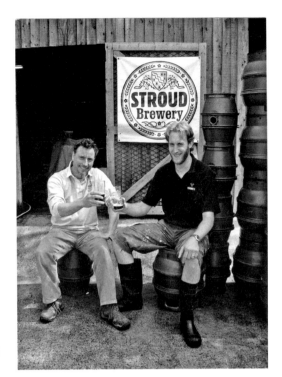

Founder Greg Pilley and Head Brewer
Ian Thorn enjoy a pint of award-winning
ale outside the new Stroud Brewery.
From its beginnings in 2005, Greg Pilley
has sought to establish the brewery in
the Cotswold community. He initiated
The Gloucestershire Craft Brewers, an
association of eight local microbreweries,
who launched the Gloucestershire Ale Trail
in 2008.

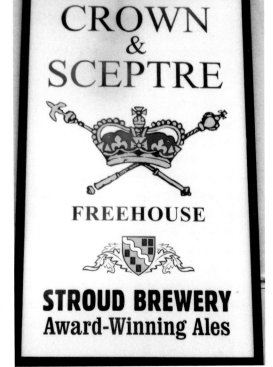

Stroud Brewery made a terrific start
with their signature beer Budding voted
as Champion Beer of Gloucestershire in
2006 and 2008. They have also won SIBA
awards for Tom Long and Woolsack Porter.
For the first time in fifty years, Stroud
Brewery is advertised on a pub sign at
the wonderfully rejuvenated and vibrant
Crown & Sceptre in Horns Road, Stroud.

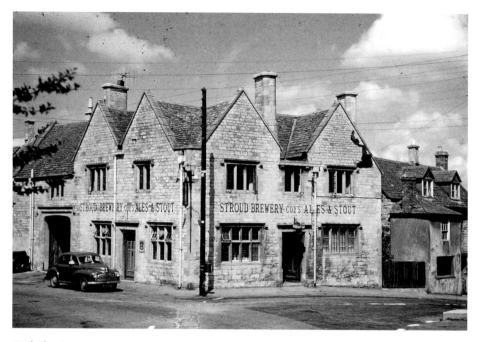

With the Crown & Sceptre, the following four pubs highlight why a visit to Stroud pubs is essential. At the Prince Albert in Rodborough, Lotte Lyster and Miles Connolly provide a rare commodity – a pub which is at once bohemian and community-centric. The ales are exceptional as are the beer festivals. Monthly comedy nights and live music add to the mix.

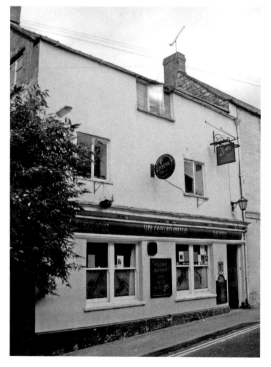

From the Prince Albert it's down and up to the Golden Fleece in Nelson Street, Stroud. Popular with Stroud's artistic locals and musicians, the Golden Fleece is a pub with the corners knocked off. T. Poole was listed as brewer here in 1856, and would surely be happy that the pub still specialises in local ales, especially from the new Stroud Brewery.

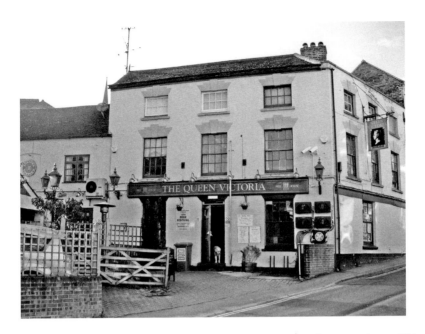

Straight down from the Golden Fleece to the Queen Victoria in Gloucester Street. This lively pub offers up to five ever-changing ales, sourced from breweries far and wide. A regular in the CAMRA *Good Beer Guide*, the Queen Vic is a town centre modern day classic with beer festivals, live music and sports TV screens.

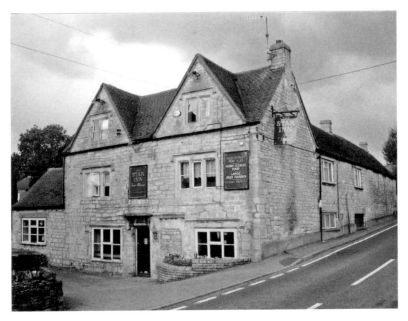

A couple of miles to the north west of the Queen Vic is the Star Inn at Whiteshill. Here landlord Ken Dickens has transformed an ailing pub into a community hub. With almost daily email updates, Ken informs locals and neighbours of Real Ale Nights and village events. Local ales are served straight from the barrel at this superb hostelry.

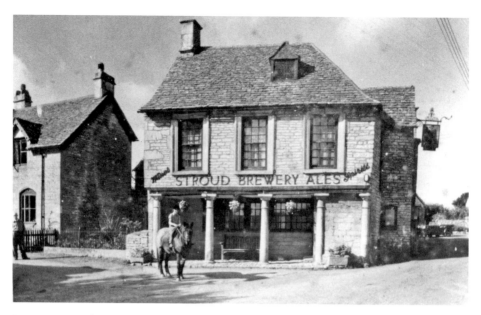

Enter expectantly under the colonnaded portico into the Poachers Bar. Sit with a tankard of ale on one of the old settles. Take in the seventeenth-century (maybe earlier) features – wonky walls, beams and inglenook fireplace. Enjoy a warm welcome and peruse the menu of daily specials. How to improve on perfection? Add a Cotswold ale or two.

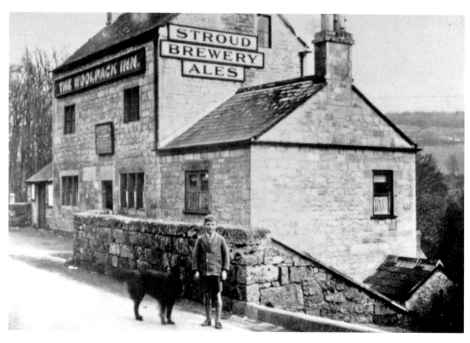

Is that the young Laurie Lee walking his dog past the Woolpack Inn at Slad? Probably not, but mementoes of the author abound in the Woolpack, even down to his bottle collection. He immortalised the Slad Valley (and the pub) in *Cider With Rosie*. The sixteenth-century authentic Cotswold inn offers Cotswold ales, mainly from the Uley Brewery.

The Skinner family were listed as brewers in Painswick from the mid-nineteenth century. Thomas Skinner & Son traded from the Bell Inn until the late 1880s. Looking down Friday Street, the Bell is pictured around 1920 when it belonged to Godsells of Stroud. It was delicensed soon after and in 1941 was destroyed by a stray German bomb.

The eye is drawn to the Butchers Arms at Sheepscombe by the unique carving above the inn sign. The pub started out as three cottages, the left of which was a beerhouse. Now the Butchers Arms occupies all three. This is a pub worth finding – a traditional rural retreat full of artefacts and with a good selection of well-kept ales.

A group of hungry and thirsty walkers gather outside the Black Horse at Cranham. It is another pub which started out as cottages – two this time. The name passed to the present pub from another beerhouse around the 1830s. The Black Horse has been a popular village local ever since and now has a varied range of refreshing ales.

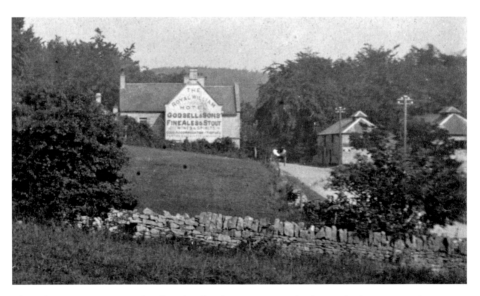

This obscure view (around a decade after brewing ceased) shows the brewery and malthouses at the Royal William, Cranham. William Sadler Hall operated his Cranham Brewery here from the late 1840s. Reputedly, Thomas Godsell's grandmother previously brewed in a barn opposite the pub and this inspired him to found Godsells Brewery. In 1904, the Cranham Brewery with eight pubs was sold to Godsells.

Cirencester Area Cotswolds

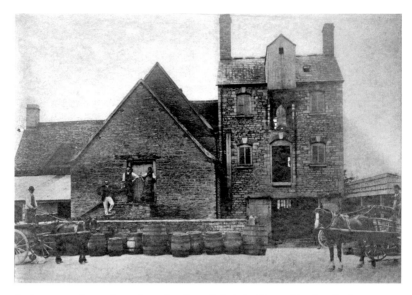

A short way from the welcoming Royal Oak in Upper Up, South Cerney, the Howell family ran a small brewery in the second half of the nineteenth century. Henry Howell retired in the 1880s and left his son Isaac Beak Howell to manage the business. When Isaac died, the brewery was sold and the tower (centre right) was dismantled.

Tucked away opposite the Eliot Arms at South Cerney, the Old George Inn was owned by the Howell Brewery until the early twentieth century. An inn from around 1700, the Old George is still an excellent venue. Three well-kept ales are served in the traditional bar and the restaurant to the rear has a pleasant mezzanine area.

An inn for around 250 years, the White Hart in Ashton Keynes was known as the Cordwainers Arms until 1851. The story goes that an enterprising shoemaker's wife started serving ale while customers waited. Beer was then brewed in what is now the skittle alley. Two centuries later, ales from local microbreweries are still sold at this very appealing pub.

At the western edge of the Cotswold Water Park, the Bakers Arms is in the tranquil village of Somerford Keynes. The pub is in CAMRA's *Good Beer Guide* and three real ales greet the weary walker or water skier. Families are welcome, especially in the large garden, and the Bakers Arms competed in the national finals for Britain's Best BBQ.

A century ago the Greyhound Inn at Siddington was tied to the Cirencester Brewery. Now it is one of Wadworth of Devizes dozen or so pubs in the Cotswolds. Up to five of their ales are available and there are eagerly awaited beer and music festivals too. The Greyhound is a genuine and appreciated village inn, with a Thai food twist.

At Ewen, the Squire closed the beerhouse in Victorian times when he heard the landlord had voted against him in a General Election. Years later, in 1937, Terence McHugh successfully obtained a licence for the Wild Duck Inn. Beautifully converted into a pub from an old barn dating from 1563, the Wild Duck is wonderfully evocative of an ancient tavern.

Once named the Great Western Inn, the name changed to the Railway Hotel in 1919. At the time the Tetbury Road Station was next door. When the station closed in the 1960s, the hotel changed name again to the Thames Head Inn. The official source of the Thames (just a trickle here) is half a mile away through fields.

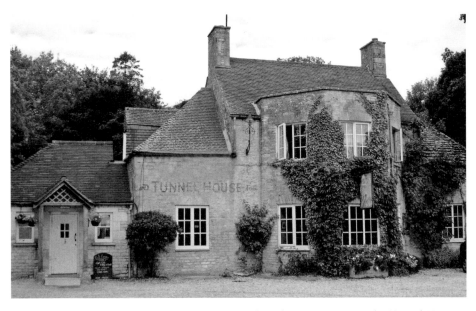

Located at the other end of the Sapperton Tunnel to the Daneway Inn, the Tunnel House at Coates rewards the journey down a bumpy track. A favourite haunt for Cirencester Agricultural College students, the pub grounds include a popular campsite. Another Cotswold gem, the interior is filled with old brewery and advertising signs. There is also a local ale or three.

Just before St John's Bridge over the Thames at Lechlade stands the superb Trout Inn. An old brochure proudly proclaims 'The 700 years' tradition of hospitality in the provision of food, drink and accommodation is faithfully maintained by the Inn today'. This continues and the pub is always busy with events and music by the river in summer.

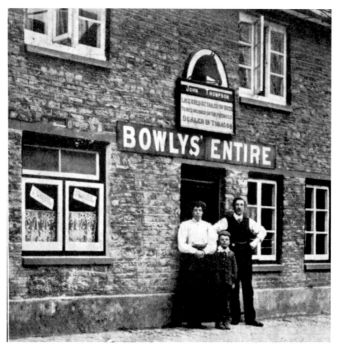

Back in town, the old Nag's Head Inn was in St John's Street. At the turn of the twentieth century the inn was supplied by Bowlys North Wiltshire Brewery, Swindon (as was the Trout Inn). Lechlade had fourteen pubs and hotels back then whereas now there are seven. Unfortunately the Nag's Head found itself "in the red" and closed.

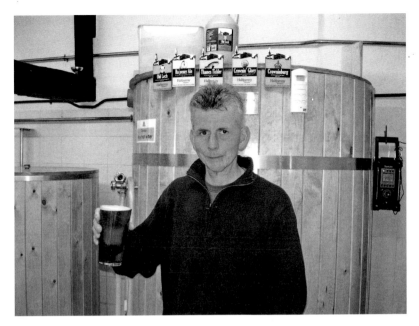

Alan Watkins (pictured) set up the Halfpenny Brewery in December 2008 behind the
excellent Crown Inn, Lechlade. The brewery is named after the town's nearby Halfpenny
Bridge. Head Brewer Graham Gerrard meticulously watches over the brewing process and
visitors can see what is going on too, as one wall of the brewery is a glazed panel.

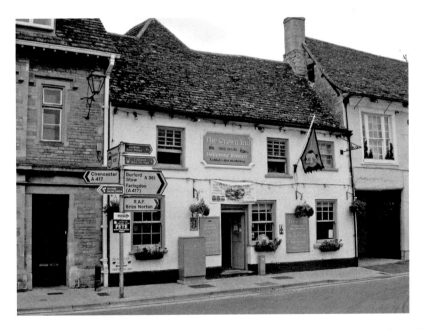

The Crown Inn, owned by Alan and his mother Valerie Watkins is a wonderful, traditional
unpretentious pub. It serves as many Halfpenny ales as possible. Beers such as Thames
Tickler and Old Lech have gone down so well that amazingly Alan is setting up another
microbrewery, the Old Forge Brewery, at the Radnor Arms in Coleshill, Oxfordshire. Hats off.

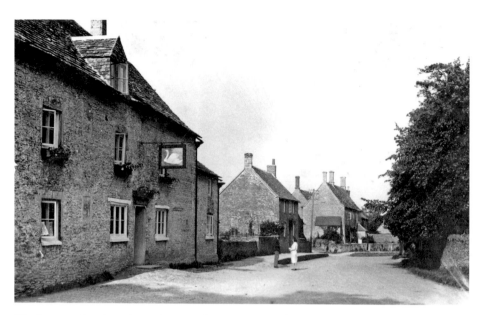

The Swan at Southrop is a rejuvenated gastro-inn, with even its own Food School. Yet turn the corner from the restaurant and there is a locals' bar with local ales, including their own badged Swan Bitter. Not a million miles away is the New Inn at Coln St Aldwyns, with its centuries old creeper covered exterior and Old King Coln badged ale.

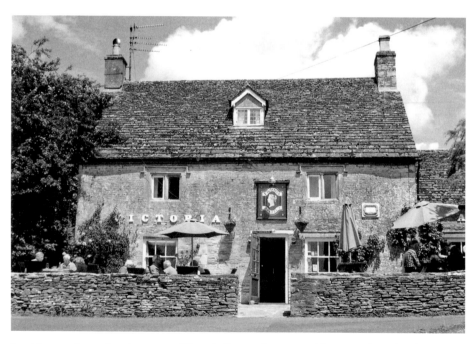

Looking out from the picturesque Victoria Inn at the pastoral beauty of Eastleach, it is hard to imagine the scene disturbed by riots. Many moons ago locals from the twin villages of Eastleach Martin and Eastleach Turville were up in arms. Thankfully peace broke out. To aid contemplation, two well-kept Arkell's ales are served at the Victoria.

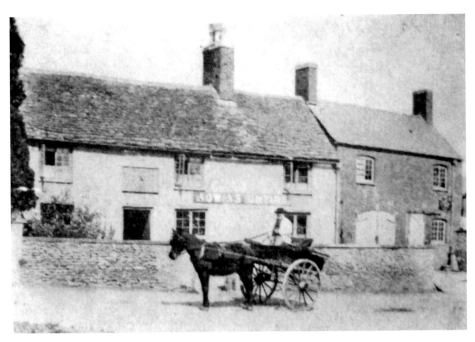

At the eastern end of Fairford, the Railway Inn has been tastefully renovated in recent years and presents four real ales, one of which is from the Halfpenny Brewery of Lechlade. Opposite the Railway, the Eight Bells Inn has been an Arkell's pub for well over a century and serves two ales. Both popular pubs provide a pleasing welcome to Fairford.

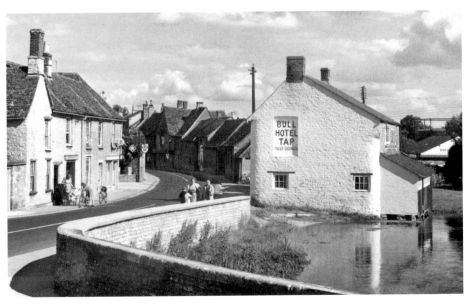

The Bull Hotel Tap began life as small refreshment rooms for coachmen and traders who worked at the Market Place in Fairford. Sadly the little smoke-filled working man's pub closed in 1957. Three hotels bordered the Market Place until several decades ago. The George and White Hart have closed but the elegant Bull Hotel is still busy.

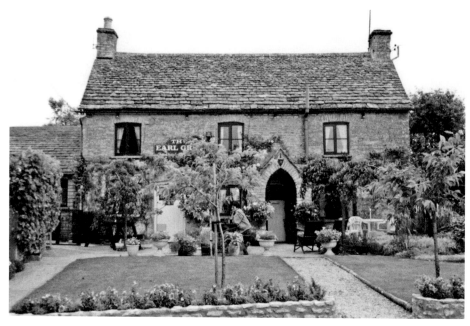

The Earl Grey at Quenington claimed to be the smallest pub in England. Certainly it was one of the quaintest. Sadly in 1996, elderly landlady Lucie Swainson poured the last pint of Wadworth 6X from the wooden barrels behind the bar. Thankfully, a few paces away the Keepers Arms still provides ale and sustenance to villagers and visitors.

By the old bridge at Bibury, the Swan Hotel (right) was very popular centuries ago during the Bibury Races. Later, it was described as 'an ancient coaching hostelry carrying on in its own traditions of complete service for the wayfarer'. Nearby in Arlington, the Catherine Wheel Inn was a far outpost of the old Nailsworth Brewery and now is a country dining inn.

A welcoming sight when coming from Cirencester on the A417, the Falcon Inn at Poulton has had an unsettled past of late. Happily the only pub left in Poulton is open again. A century ago the Falcon was a spartan Cirencester Brewery alehouse. Now it is a very comfortable one bar, food-led pub which still offers ale to quench farmworkers' thirsts.

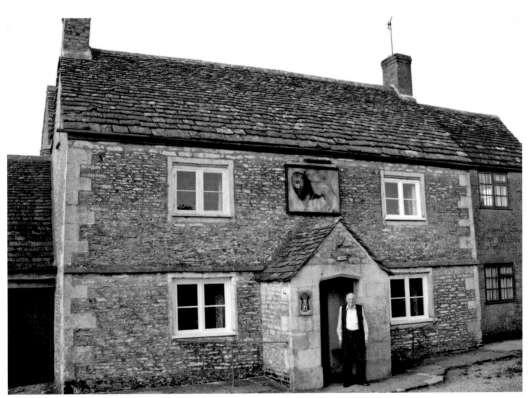

One of the nation's last 'parlour pubs', the Red Lion Inn at Ampney St Peter is joint third on the list of 'Classic Unspoilt Pubs of Great Britain'. If such a list existed for landlords, John Barnard (pictured) would surely be top. There is still a Codd bottle opener screwed to a cupboard. There is no bar counter here. Cheers John.

AMPNEY CRUCIS

NEAR CIRENCESTER.

Particulars and Conditions of Sale

— OF A SMALL COMPACT —

FREEHOLD BREWERY

Comfortable Residence & Premises, Malt Houses, Garden Ground,

— AND —

FREE LICENSED BEER HOUSE

called the "Butchers' Arms" Inn,

SITUATE IN THE VILLAGE OF AMPNEY CRUCIS,

The Property of Mr. CHARLES RADWAY, who through ill-health is giving up the business, which will be offered for SALE BY AUCTION, by

MR. C. F. MOORE

At the King's Head Hotel, Cirencester,

On MONDAY, the 4th day of SEPTEMBER, 1899,

At FIVE o'clock in the Evening, in one or more lots, which may be determined on at the time of Sale.

☞ To view the Property apply to Mr. CHARLES RADWAY, and for further particulars to the AUCTIONEER, Corn Hall Buildings, Cirencester, or to

MESSRS. SEWELL & SONS,

Solicitors, CIRENCESTER.

The Radway family brewed at the Butchers Arms at Ampney Crucis in the second half of the nineteenth century, but the small brewery, along with the inn, was sold to the old Stroud Brewery in 1899. After the sale, brewing ceased at Ampney Crucis. With a reputation as a basic locals' pub, the Butchers Arms survived until 1997 and is now a private house.

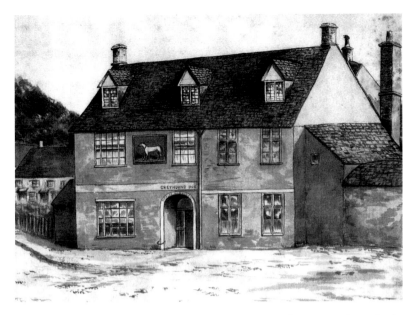

At Barnsley, near Cirencester, the Greyhound Inn was painted in 1895 when Charles W. Bridges was landlord. Around the 1920s the licence transferred to the current Village Pub which took the name of the Greyhound for a while. The original inn is now Greyhound Farmhouse. Additionally the Clements family brewed at Church Farm for generations, with the brewhouse extant.

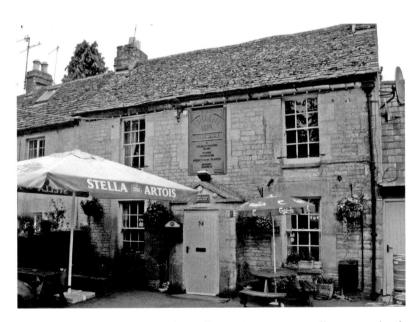

At Stratton, even nearer Cirencester, the Drillmans Arms is an excellent example of a thriving community pub. Four ales are served including ones from the superb Vale Brewery at Brill, Bucks. Nearby in Albion Street, opposite the old Salutation Inn, was the old Stratton Brewery. Operated by Thomas Hayward and then Edward Woodman, it was sold to the Cirencester Brewery in 1889.

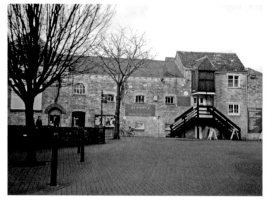

The Cripps family were probably involved when the Cirencester Brewery was founded in 1798. Certainly the family were owners from the early nineteenth century. In 1882, Edward Bowly's Cotswold Brewery in Watermoor Road was acquired with sixteen pubs. However, H & G Simonds bought the Cirencester Brewery in 1937 and it was mostly demolished (except for a section later renovated – pictured).

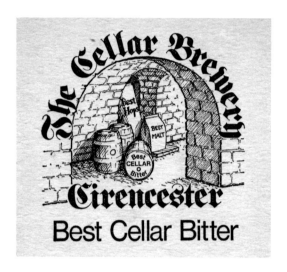

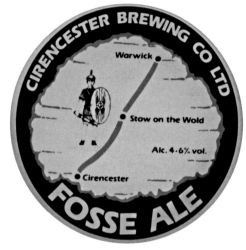

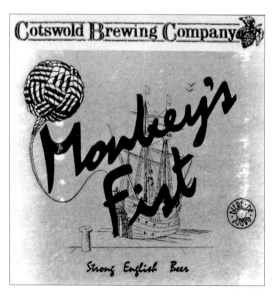

In the cellars of what was the old Cirencester Brewery and is now the New Brewery Arts, three breweries tried to establish themselves in the 1980s. The Cellar Brewery was launched in 1983. This became the Cirencester Brewing Co Ltd in 1986 but closed soon after in 1987. In 1988 the short-lived Cotswold Brewing Co began but closed in 1989.

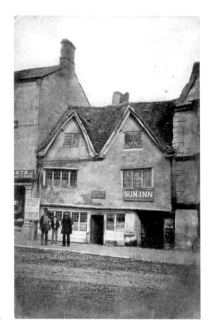

The Sun Inn was typical of many ancient dilapidated beerhouses. Next to the Fleece Hotel in Cirencester, the Sun was forcibly closed on 3 March 1922 by the Compensation Authority. The Authority had the power to shut decaying pubs and compensate the owners, in this case the Cirencester Brewery. A more modern scourge is repossession. The Twelve Bells is sadly missed.

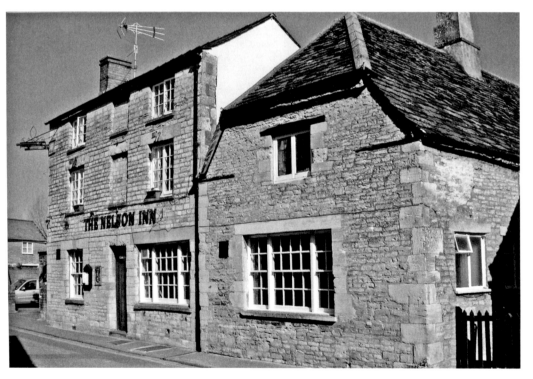

In Gloucester Street, Cirencester, the Nelson Inn's centre window replaced an archway leading to a small brewery. The Nelson Brewery operated for over 120 years up to 1930 and now houses the Function Room. It is still a great pub and, what's more, in 1963 the Nelson became the first 'theme pub outside London' with a remarkable nautical makeover.

Around 1830, William Waine started brewing at his farmhouse in Aldsworth (malthouse and brewery on right). After he died in 1858, the house and brewery were sold to John Walker Tayler who had already established a brewery at Northleach. After his death in 1879, his wife Elizabeth carried on the brewery at Aldsworth but by 1900 the business had transferred to Northleach.

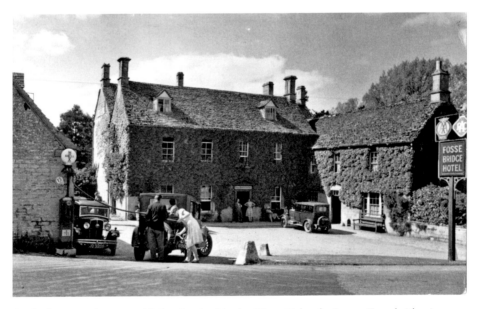

At the bottom of a steep-sided valley beside the River Coln, the Inn at Fossebridge is a 300 year old former coaching inn. In days gone by it stabled extra 'trace' horses to help carriages up the steep slopes. Today, the hotel's Bridge Bar is superb, with local ales and probably the largest flagstones in the western world.

The Tayler family established a brewery (centre right) at West End, Northleach in the mid-nineteenth century. Known either as the Northleach Steam Brewery or the Cotswold Brewery, it had seven tied houses nearby. Of these, the Sherborne Arms and Wheatsheaf Hotel are still serving ale. The business of Tayler & Co. was acquired by the Cheltenham Original Brewery in 1919.

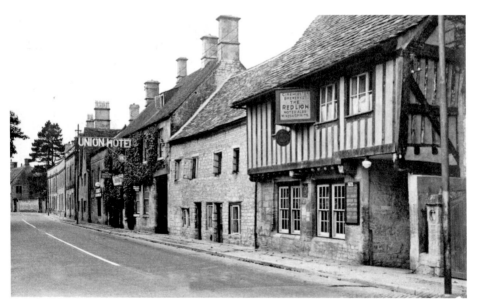

Taken when the Red Lion at Northleach was a Cirencester brewery tied house, the postcard also shows the old Union Hotel. The renowned hotel was once owned by the local Taylers Brewery but unfortunately closed in 1994. The ancient Red Lion continues to be a lively pub well worth visiting with a changing selection of ales, including local beers and milds.

Local stories recount that Smuggs Barn in Chedworth was a haven for smugglers who operated from Gloucester docks, hence its name. Cider was made at this most basic of inns in the nineteenth century, and ale was supplied from Cirencester by the Nelson Home Brewery and Cripps Brewery. The characterful rural alehouse closed for good in 1925.

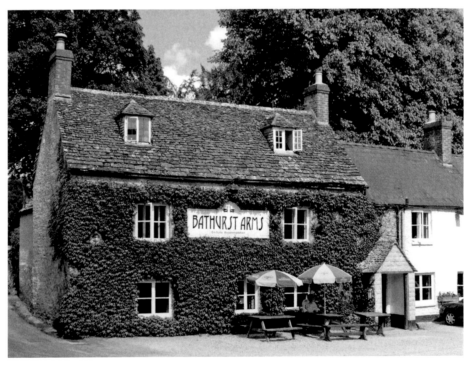

Set in the picturesque Churn Valley with a riverside garden, the Bathurst Arms at North Cerney provides everything the discerning pub-goer could desire. The appealing exterior draws the visitor into the seventeenth-century hostelry. Inside, original features abound and there are three well-kept Cotswold ales. The service, food, wine and accommodation are all very well reviewed.

An inn of sublime quaintness, parts of the Mill Inn at Withington date back 500 years. In living memory, lines of churchwarden pipes waited above the fireplace for locals with their pints of Cheltenham Original Brewery ale. The Mill Inn still possesses traditional charm, but only has keg beer supplied by owners Sam Smith's of North Yorkshire.

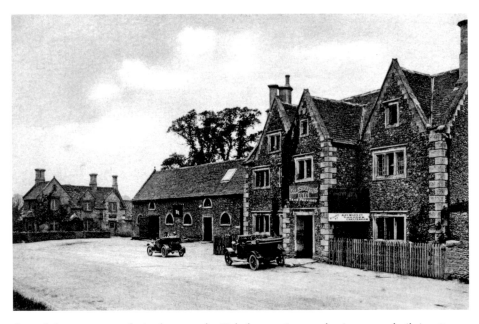

One of the youngest pubs in the area, the Colesbourne Inn on the A435 was built in 1827. The inn is now owned by Wadworths who are slowly adding to their Cotswold estate through select acquisitions. With up to three ales available, there is plenty of room for drinkers and diners. Nearby Colesbourne Park is world famous for its Snowdrop Collection.

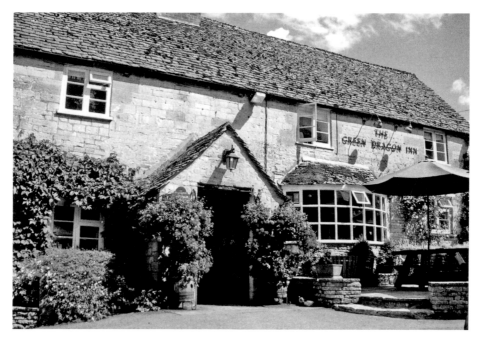

The superb Green Dragon at Cockleford is the type of rural hostelry that these days has to provide tradition, quality and great service in order to survive. These are delivered in spades and explain why the Green Dragon is so highly rated. The wonderful award-winning Five Mile House at Duntisbourne Abbots is nearby and well worth a visit too.

On the ancient Roman Ermin Street, near Elkstone, the grand old Highwayman Inn was previously called the Masons Arms. Prior to that, it was the Huntsman & Hounds. Now it stands beside the A417 dual carriageway but once inside, the warm welcome, traditional features and four foaming Arkell's ales help the visitor imagine stagecoaches (like in the car park!) rolling by.

East Cotswolds

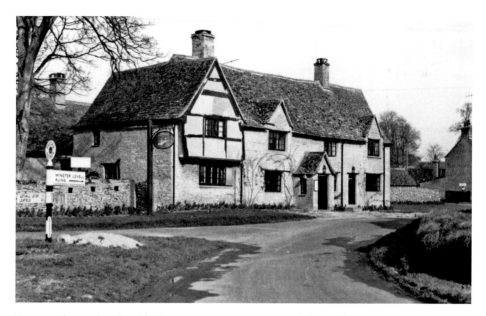

Beer was brewed at the Old Swan at Minster Lovell until the mid-nineteenth century with farmhands allowed twelve pints of 'home brewed' on sheep dipping days. The classic fifteenth century inn has been beautifully restored and is allied to the adjacent Mill Hotel. Behind the inn, rescued battery hens have their own luxury Cotswold stone accommodation.

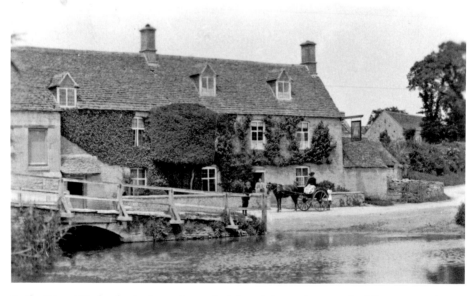

By the River Windrush, the Swan Inn at Swinbrook is another wonderfully renovated former brew-pub. Locally sourced food is served along with local ales, and photographs of the Mitford family adorn the walls. Responding to market demands, the Swan is a country dining pub but also strives to be at the heart of the local community.

An old Clinch of Witney pub, the Masons Arms at Fulbrook is a friendly village local. A previous landlord, Martin Robinson, was an ex-sailor and called 'time' by blowing a naval whistle and shouting 'Heave-Ho me hearties'. Due to its restricted opening hours, thirsts can also be quenched in the Carpenters Arms at the other end of the village.

South of Burford by the A40 roundabout stands the Cotswold Gateway Hotel. Until about 1863, ale was brewed here at an earlier inn – The Bird in Hand, which closed when the coaching trade declined. As motor car traffic increased, the old inn was refurbished and reopened in 1928 as the Cotswold Gateway. Real ales are still dispensed.

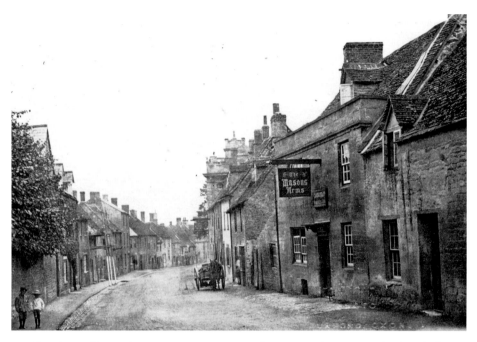

Looking down Witney Street a century ago, past the Masons Arms (now the Angel) the sign for the Royal Oak is visible above the horse and cart. Then a Garnes pub, it is now owned by Wadworth of Devizes. The Royal Oak is a gem of a traditional pub and well worthy of its inclusion in the CAMRA *Good Beer Guide*.

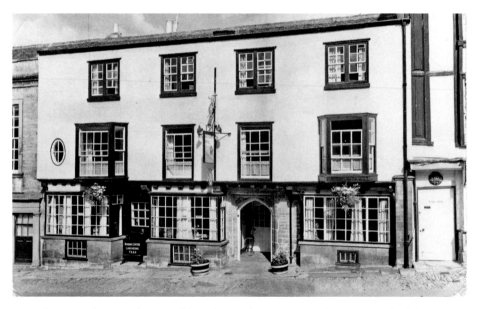

Over the years, dozens of inns and beer houses have come and gone in Burford, but enough survive in the High Street alone to reward a trip to the town. The Highway Inn (pictured), Golden Pheasant, Mermaid and Cotswold Arms serve a varied and changing range of ales with local breweries well represented.

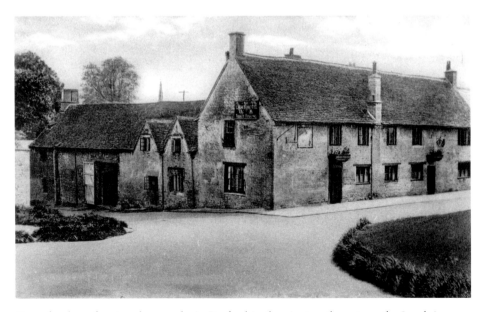

HERE IS **BEER**

AT PRE-WAR STRENGTH

MALT & HOPS

Garne & Sons
BURFORD

9/- PER DOZ. PINTS. **5/-** PER DOZ. HALF-PINTS.

Try *it at* **St. GEORGE'S CAFÉ,** OXFORD.

Buy *a dozen at* **GRIMBLY HUGHES,** OXFORD.

The Burford Brewery in Sheep Street was founded in 1798 (possibly earlier) and ownership passed through the Tuckwell, Streat and Reynolds families until it was bought by George Garne in 1880. Garnes beer had a good reputation locally but the business was acquired by Wadworth in 1969 with nine pubs. The advert comes with authentic Garnes beer stains.

One of at least fourteen brew-pubs in Burford in the nineteenth century, the Lamb in Sheep Street is a classic hostelry. The Wyatt family were at the Lamb for seventy-five years and brewed there into the early twentieth century. The inn was extended in the 1940s and now includes an award-winning hotel. There are lovely gardens to the rear.

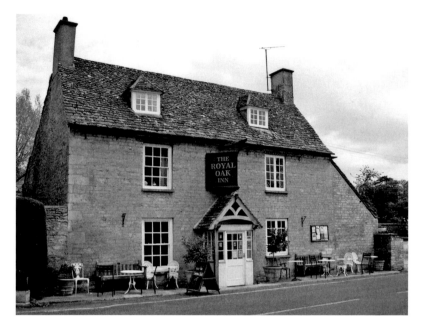

The Royal Oak is the only pub in Ramsden after the Stag and Hounds closed many moons ago. Run by Jon and Jo Oldham since 1987, and with loyal staff, the welcome is one of the warmest in the Cotswolds. Famed for fine ale, food and wine, the traditional rustic interior is a joy. The poor mobile phone signal encourages conversation.

Well worth seeking out at 'The Bottom' in Finstock, the Plough Inn is a very appealing freehouse with plenty of traditional charm. Ale quality is excellent and has resulted in regular recent CAMRA *Good Beer Guide* inclusions. Draught ciders are also available. Pubs like the Plough are all too rare and must be cherished.

There are today three pubs and one hotel bar in the centre of Charlbury – Ye Olde Three Horseshoes (excellent friendly local), Bull Inn (super dining pub), Bell Hotel (pictured – smart welcoming bar) and the Rose & Crown. The last is a multi CAMRA award-winning, wet sales only, true champion pub with an ever changing beer selection. Charlbury station is nearby.

Leafield is not a complete village. It has a church, a school, Post Office and even a Community Wood. But no pub. The Old George Inn (pictured) closed several decades ago, the Navy Oak (previously Potters Arms) several years ago and the Fox several months ago. However, moves are afoot to reopen the Fox and make Leafield whole again.

When the railway arrived in Ascott-under-Wychwood in the 1860s, the Churchill Arms (pictured) was built. Over one hundred years later it served its last pint, leaving the Swan as the only pub in the village. Despite good reviews, unfortunately on 20 June 2010 the Swan closed too. The landlord cited lack of trade as the main reason.

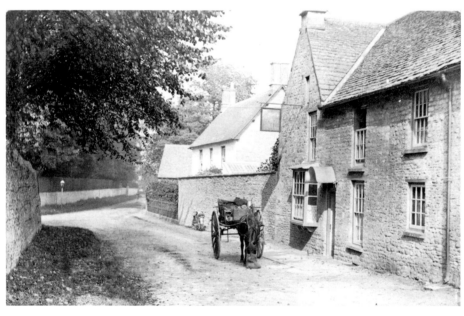

Like the Swan at Ascott, Butchers Arms at Milton and Shaven Crown nearby, the Lamb Inn at Shipton-under-Wychwood was a home brew-pub. However, brewing seems to have ceased at all four pubs by the 1860s. Now the Lamb is a very smart pub with a restaurant and letting rooms. The walls in the bar are covered in Cheltenham Races memorabilia.

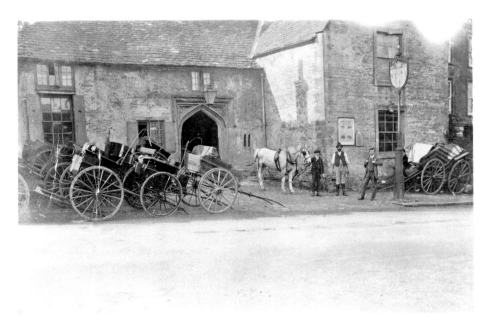

In Shipton-under-Wychwood, the Shaven Crown Hotel takes its name from the shaven tonsure of the monks from Bruern Abbey who built the wonderful structure in the fourteenth century. Previously just the Crown Inn, local ales are served in the characterful Monks Bar through the arch and courtyard to the left.

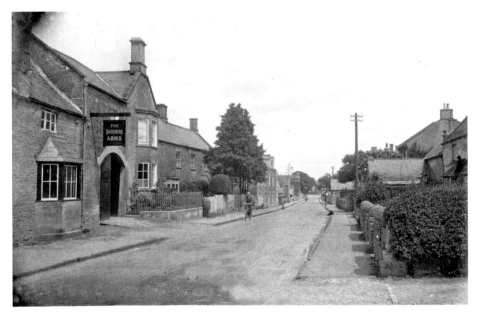

The name 'Clinch' can still be made out on the arch of the old Butchers Arms in Milton-under-Wychwood. The pub closed in 1970. Further down the High Street, the Quart Pot remained at the heart of the village. Despite favourable reviews, an entry in the CAMRA *Good Beer Guide* and supporting community activities, it closed in early 2010.

After the Malt Shovel and Sandys Arms closed, Chadlington residents fought Bass brewery in 1984 to keep the Tite Inn open. The name derives from a local word for 'stream' – which runs under the CAMRA award-winning pub into a trough. Today it is renowned for its ales, food and quirky events such as Easter Egg Rolling and Great Brook Run.

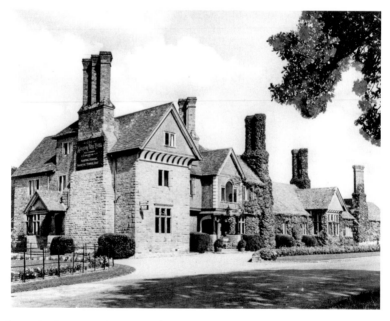

At Kingham, the Langston Arms Hotel is now a residential home. However, in the 1960s, an exorcism was carried out to rid the hotel of a presence described as 'a faintly luminous Victorian female'. Kingham still has a hotel – the Mill House, and two pubs – the Tollgate and Kingham Plough. Both serve local real ale and are tastefully renovated luxurious country dining pubs.

Cotswold Lager? Oh yes. Richard and Emma Keene established The Cotswold Brewing Co. in 2005 at Foscot. They are now multi award-winning artisan lager producers and are founder members of LOBI (Lagers of the British Isles). Their lagers taste brewed not manufactured, and are full of flavour. Success means expansion in to larger premises over summer 2010.

Mattias Sjöberg of the Compass Brewery stands between the mash tun and copper at Foscot. Their first beer was ready in November 2009 and the intention is to brew adventurous ales using technical recipes. Already Compass has won acclaim for Baltic Night Stout and has launched The King's Shipment IPA and Isis Pale Ale. Mattias also hosts tutored beer and whisky tastings.

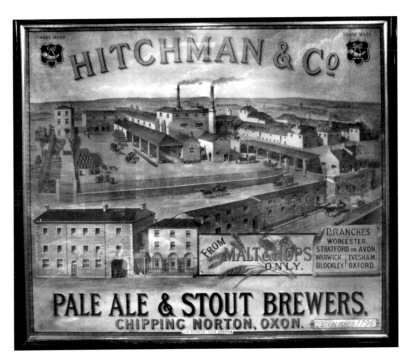

At Chipping Norton, the commercial brewing business of Hitchman & Co. was founded in 1796. The large premises depicted in Albion Street were built in 1849 and known as the Borough Brewery. In 1924 the business (including thirty-six pubs) amalgamated with Hunt Edmunds of Banbury. Brewing ceased in May 1933. The old offices (bottom left) survive in West Street.

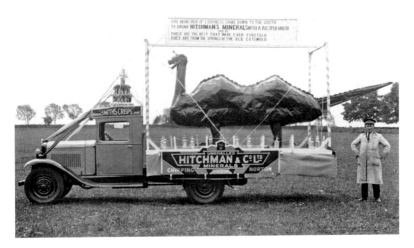

The sign atop the carnival float reads 'The monster of Loch Ness came down to the South, To drink Hitchman's Minerals with a big open mouth. Said he, "These are the best that were ever foretold, They are from the springs of the old Cotswold."' Soft drinks production under the Cotswold Spring brand continued at Chipping Norton until 1967.

In Goddards Lane, The Chequers has twice been Fullers Pub of the Year. It was among at least fifteen brew-pubs in town during the nineteenth century. Today Chipping Norton has pubs owned by Hook Norton (Red Lion, Fox Hotel and Albion Tavern), Arkells (Kings Arms), Fullers and several freehouses. Beer choice is excellent and local ales are well represented.

Pictured from left to right: the Blue Boar (old brew-pub, still a good pub). Opposite was the Blue Anchor (old brew-pub, long closed). Through the second archway was Henry's Butchers Yard Brewery from 2000 to 2002 (they brewed Chippy Best). Far right is the Crown and Cushion Hotel (old brew-inn with comfortable real ale bar. Once owned by Keith Moon!)

Straying slightly from the Cotswolds, the Falkland Arms at Great Tew is a picture postcard pub with a bucolic interior. Locals love it – in fact in the 1970s it was run by villagers when threatened with closure. A bottled Royal Wedding Ale was produced in 1981. Now it is a Wadworths house and has an eagerly anticipated annual beer festival.

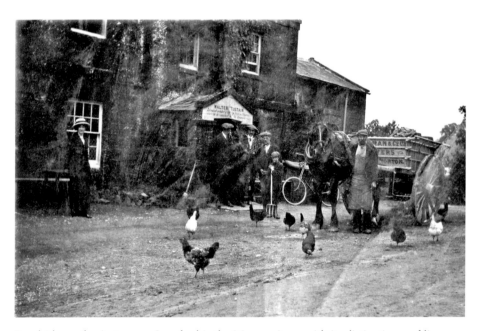

Roadside on the A361 near Swerford is the Masons Arms with its distinctive roof line. Once a Hitchman's house (their dray is delivering to landlord Walter Tustain) then Hunt Edmunds, it even sold Esso petrol at one stage. Now with Bill Leadbeater at the helm, it is named in the nation's top 100 pubs for eating out.

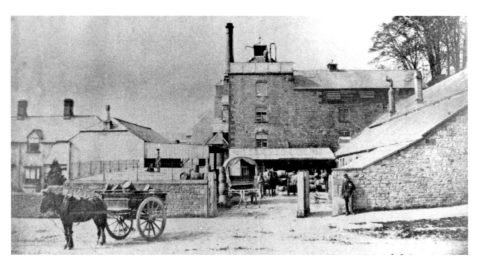

At the junction of Brewery Row and Malthouse Lane in Little Compton stood Henry Lardner's Steam Brewery. Established in 1860, it grew to own thirty pubs. The brewery manager lived in the end cottage and Henry in the large house opposite. Due to declining trade and bad debts, in 1898 the business was sold to Hitchman's and Flowers breweries.

The Aunt Sally back cloth at the Red Lion, Little Compton. Aunt Sally is played exclusively in Oxfordshire and bordering areas of neighbouring counties. The aim is to cleanly knock a stubby skittle or 'dolly' off a swivel, inserted into a rod or 'iron', with round-ended sticks from thirty feet. A competitive league is in operation.

Landlords Jamie Powell and Esme Mitchell at the Red Lion serve excellent Donington ale and delicious food. They were previously at the equally superb Greyhound at Sydling St Nicholas, Dorset.

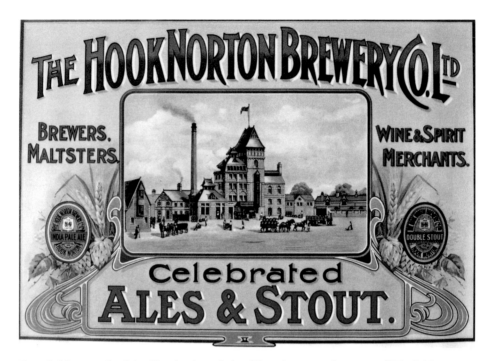

Founded in 1849 by John Harris, the existing Victorian tower brewery of Hook Norton was completed some fifty years later. The old steam engine continues to work and beer is delivered locally by horsepower even today. The business is still independent, has forty-seven pubs and is run by the fifth generation of the founder's family.

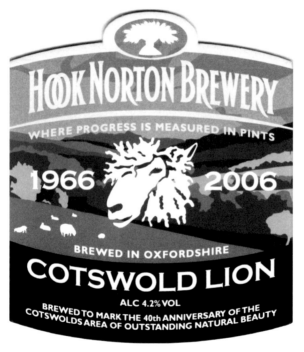

As a measure of quality, Hook Norton won four Gold Medals (for Double Stout, Haymaker, Twelve Days and Old Hooky) at the International Beer Challenge in 2009 – more than any other brewer. In 2006, Cotswold Lion was brewed to celebrate the Cotswolds AONB 40th anniversary. The golden fleeces of the sheep with a woolly 'mane' created the Cotswolds wealth.

At the other end of Brewery Lane, the top of the tower peeps over the Pear Tree Inn. It has been the brewery tap since 1869 (although the Visitor Centre, opened in 1999, is now closer!). There is always a warm welcome at the eighteenth century pub and the beers – the full range – are all in tip-top nick.

Just north of Hook Norton on the old drovers' road from Wales to London stands The Gate Hangs High. Frequented by highwaymen, Dick Turpin reputedly spent a night here. A brew-pub in the nineteenth century, the name derives from the toll gate nearby. Today the pub has a homely and traditional feel and provides foaming Hook Norton ales.

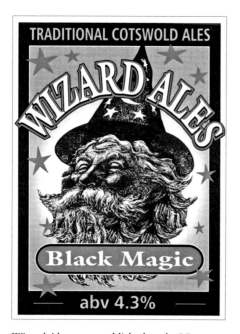

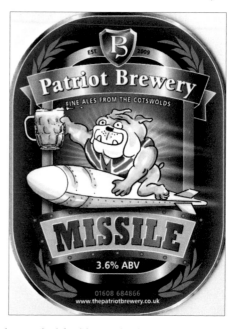

Wizard Ales was established at the Norman Knight in Whichford by Michael Garner in 2003. The beers (e.g. Apprentice, Sorcerer and White Witch) and pub won many awards. In 2007, Michael moved to Ilfracombe where he has won a Tesco Award for Druids Fluid. Enter Tim Young and Matt Findlay who re-established brewing behind the pub with the Patriot Brewery.

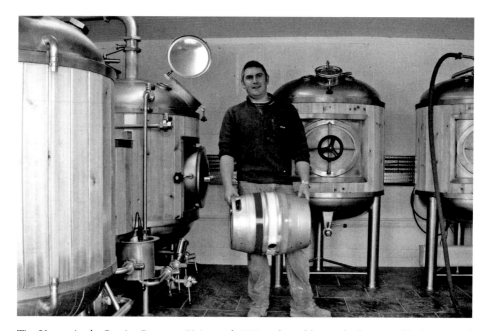

Tim Young in the Patriot Brewery. Using only UK malt and hops, the brewery hit the ground running with the launch of Missile – 288 pints were sold in 42 minutes! Beers such as Nelson, Longbow and Bulldog are following. The Norman Knight (formerly the New Inn) has been sympathetically extended, serves fabulous food and is a beer drinkers' paradise.

During the Second World War, a friendly farmer gave the Red Lion at Long Compton some cider. But it was undrinkable – until American GIs stationed locally were generously allowed to finish the barrel. Today the Red Lion is a smart country dining pub with superior accommodation. Nearby, the Cherington Arms is a lovely village Hook Norton Brewery pub with its own badged ale.

Definitely worth finding at Great Wolford is the Fox & Hounds. An atmospheric sixteenth-century country inn, it has a proper bar as well as eating areas. Top notch ales are served, many from local microbreweries. The inn sign is double sided and depicts the sticky end of a recent prime minister who presided over the banning of fox hunting.

The Taylor Brothers operated a brewery at Upper Brailes from 1900 to 1926. The family also developed patent tap jars and optics, and this diverted their attention from brewing. After closure, the brewery sign was overpainted 'Brailes Band Rooms' but this was painted out in the Second World War in case of invasion. In the loft, a slate bed is all that remains of the original equipment.

Adjacent to the old brewery, the Gate Inn is an award-winning, well reviewed community pub. Now owned by Hook Norton, the Gate is a friendly, unpretentious local, valued and similarly offering good value. At Lower Brailes, the George Hotel is another award-winning Hook Norton house. With parts dating to the fourteenth century, the George is a wonderful, rambling old coaching inn.

North Cotswolds

Now you're in Donnington Country. Situated between Great and Little Barrington, the Fox Inn is a pub-goers' pub, a real pub. The traditional seventeenth-century inn is in a tranquil, idyllic location beside the River Windrush. The Fox is owned by the Donnington Brewery, and BB and SBA are served. On August Bank Holiday, the Foxstock music festival is a real highlight.

At Bourton-on-the-Water, the northern wing of Harrington House (right) was used as a brewery from the 1860s by Hadley & Sons. Immediately left of Harrington House in Sherborne Street, the Jubilee Inn was established for a short time around the turn of the twentieth century by Alfred Hadley and sold his Bourton Brewery ales.

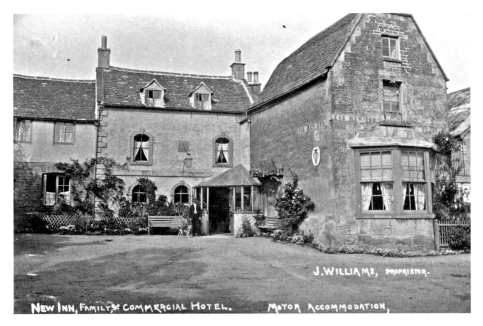

The Old New Inn was just the New Inn when J. Williams was proprietor. The 'Old' was added on completion of an extension in 1938. Uniquely, it has a one-ninth scale model of Bourton-on-the-Water in its back garden. An elegant hostelry, the inn has three bars and sponsors a team in the annual Football in the River match.

In Bourton, the Woodman Inn and Lansdown Inn both had brewhouses in use in the nineteenth century. The Lansdown became the Mousetrap Inn (pictured) from the 1930s, some say as it only had one door and it was difficult to slip out unnoticed. Now the Mousetrap, with its varied and changing range of local beers, is a true Champion of Cotswold Ales.

The Plough Inn used to be in Cold Aston and Aston Blank. Strangely the village had two names, the former used by the Post Office and the latter by Ordnance Survey. A committee decided on Cold Aston. The Plough was an outpost of Dunnells Brewery of Banbury a century ago. Today the welcoming inn offers local beers and Cotswold lagers (including a Dark).

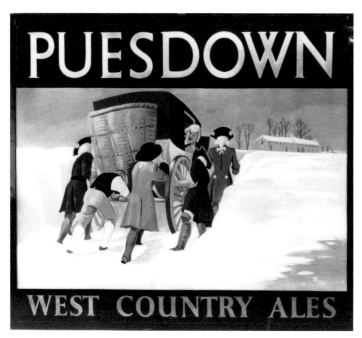

High up on the Cotswolds by the A40 near Hazelton, the Puesdown Inn has been a welcome sight for centuries. Its exposed position is depicted in the 1960s inn sign painted by the renowned Mike Hawkes. The Puesdown is a cheerful, characterful inn serving Hooky ales and its walls are adorned with numerous pictures and prints. The loos must be experienced too!

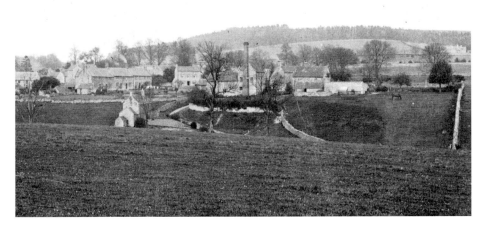

The only known image of the Brockhampton Brewery while it was in operation. In 1840 the Coombe family acquired the brewery which was already in existence. They ran the brewery for eighty-seven years before the goodwill was sold to Showells Brewery. Homebrew kits were sold until 1939 to make a utopian beer on which 'our forefathers thrived and lived happily together.'

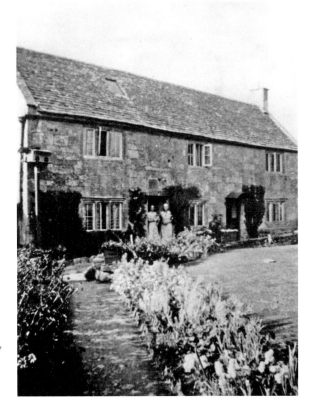

From the road to the old Brockhampton Brewery, the back wall of the Craven Arms confronts visitors. Don't be deterred. Enter from the side and a cosy bar with four ales awaits. There is an annual beer festival too. Mrs Millicent Wallbank and daughter Laura never sold ale from the brewery next door – the pub was tied to the Cheltenham Original Brewery.

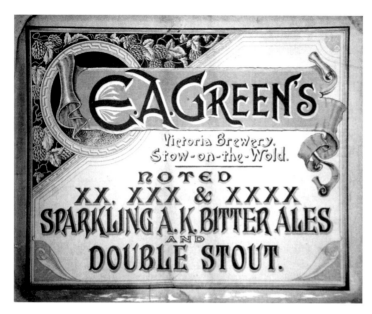

The old Victoria Brewery in Sheep Street, Stow-on-the-Wold dates from around 1837. It passed through the hands of Beman Charles & Fletcher, the Gillett family, Tusker, Lowther & Barker and the Green family. Edwin Augustus Green brewed there from around 1895 to 1911 and Augustus Barton Green from 1911 to 1914, when it was sold to the Cheltenham Original Brewery with fourteen pubs.

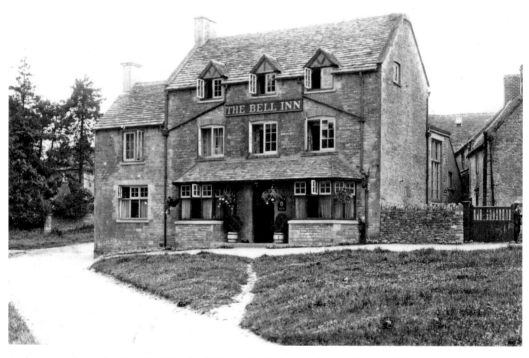

A short way from the Royalist Hotel which was built in 947 AD and is the Oldest Inn in England, the Bell Inn has views over the Oxfordshire Cotswolds. The Bell, rebuilt on the site of the former Royal Oak around 1850, is one of the youngest hostelries in Stow. After an uncertain few years, the Bell has now returned to form.

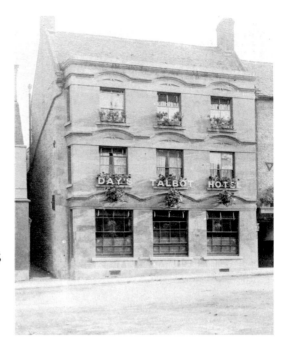

Owned by the Day family for the second half of the nineteenth century, the Talbot Hotel in The Square, Stow, was always busy with carriages and posting horses. Across Sheep Street, parts of the sign DAY'S TALBOT HOTEL STABLES are still visible on Durham House. The Talbot is a hotel no more, but is a popular bar serving ales from new owner Wadworth.

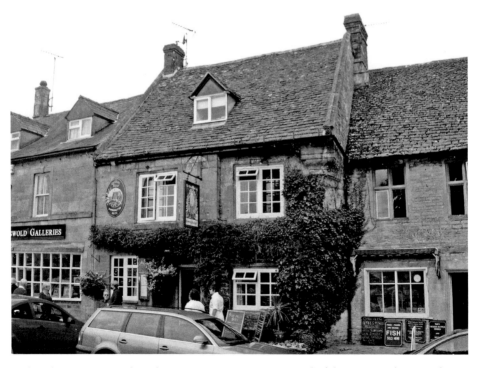

Today, the Queens Head in The Square, Stow, retains a wonderful country pub atmosphere in a picturesque town setting. The seventeenth century inn must have been one of the Donnington Brewery's first acquisitions as it was sold to the Arkell family in the 1860s. Previously, in 1848 it was put up for auction with a brewhouse listed in the sale document.

Oddington is blessed with two great pubs – the Fox at the Lower end and the Horse & Groom at the Upper end. There is little to choose between these two belters. The Horse & Groom has been beautifully renovated in traditional style while the Fox has a more olde worlde, multi-roomed appeal. Both serve a selection of well-kept local and guest ales.

The Fox Inn at Broadwell is a busy, inviting, proper country village pub. Indeed it was CAMRA North Cotswold Pub of the Year in 2007. Sitting on the edge of the village green, the 400 year old family run Fox was formerly a farmhouse. As a Donnington Brewery tied house, excellent ales are served along with unpretentious home-cooked meals.

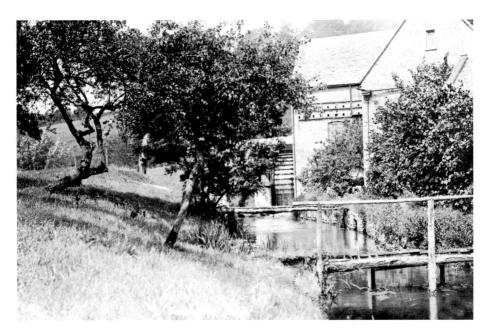

Occupying the most idyllic setting, the Donnington Brewery is also the 'Home of Pure Beer', which locals claim leaves no hangover. Established in 1865 by Richard Arkell, the brewery was run in the same traditional manner incorporating the waterwheel by Claude Arkell (Richard's grandson). When Claude spoke of the '60s, he referred to the 1860s!

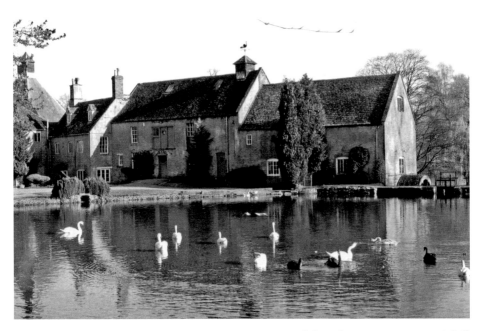

Sadly, Claude died in 2007. The Donnington Brewery was left to distant cousin James Arkell of the Kingsdown Brewery in Swindon. Under his leadership, Donnington won the *Good Pub Guide* Brewery of the Year 2010. Most ramblers' idea of heaven, Donnington's fifteen pubs form a sixty-two mile circular walk appropriately called 'The Donnington Way'.

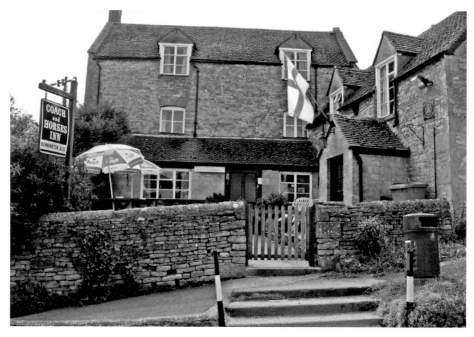

From 1963 to her retirement in 2009, Connie Emm ran the Coach & Horses at Longborough, latterly on her own. She was from the old school of pub landladies. Food was not normally available – a note 'No food served here' greeted customers on one visit. The inn was the only regular outlet for Donnington's XXX Mild. Now wholesome food is served.

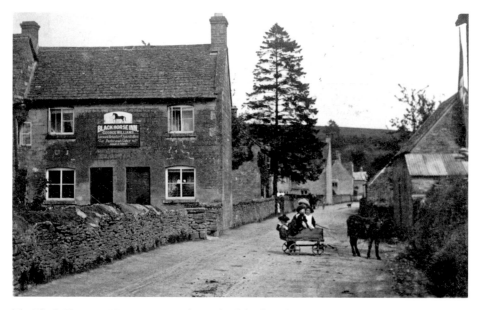

The Black Horse at Naunton is another splendid village local owned by Donnington Brewery – is there a theme emerging here? A century ago, when George Williams was landlord, the inn was tied to Greens Stow Brewery and sold Bitter A.K. Ale and Brown Stout. Donnington BB and SBA are now served from the welcoming bar which is festooned with hops.

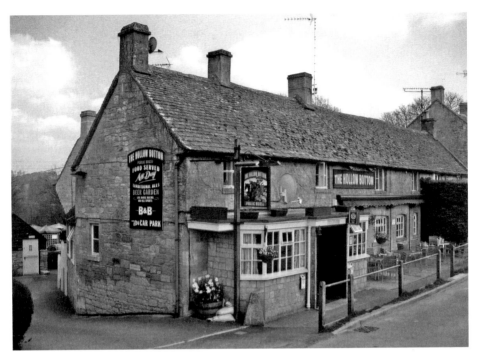

After the 2010 Cheltenham Festival, Imperial Commander with trainer Nigel Twiston-Davies drank champagne from the Gold Cup outside The Hollow Bottom at Guiting Power. The Hollow Bottom is a racing-mad pub with its own badged ale. Its name changed from Ye Olde Inn when it was bought by a group of trainers including Raymond Mould and Twiston-Davies in 1996.

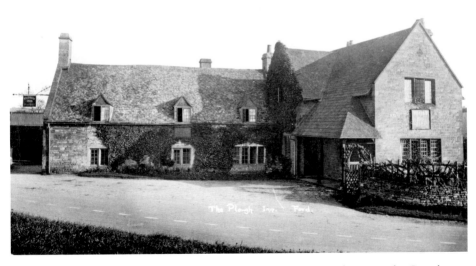

In 2010, the Cotswolds is home to two classic winners. Don't Push It won the Grand National and gave jockey Tony McCoy his first National triumph in fifteen attempts. The celebration party was held at the sublime, ancient Donnington Brewery-owned Plough Inn at Ford. Trainer Jonjo O'Neill's Jackdaws Castle training grounds are a gallop away.

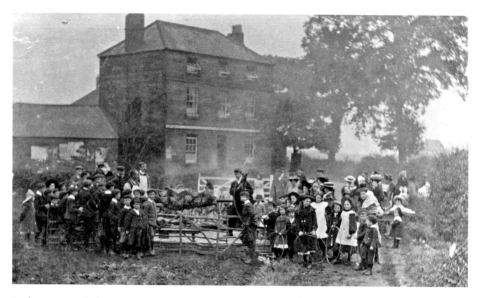

Perhaps a spark from an ox roast like this caused the Wellington Inn in Moreton-in-Marsh to catch fire in 1905. It was rebuilt and is located on the A44 London Road. The 'Wellie' had been one of four inns in Moreton tied to Lardners Brewery of Little Compton. Today, it is a friendly, welcoming Hook Norton Brewery pub.

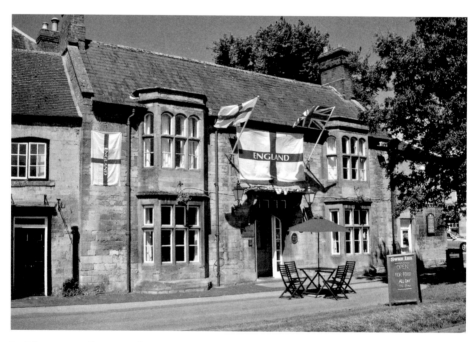

In Moreton High Street, the eighteenth century Swan Inn still welcomes guests. During the 1880s, customers drank ale brewed there by Joseph Octavius Gillett. However, Taylers Northleach Brewery acquired the Swan by 1891 and the brewery moved up the road, next door to where the Tourist Office is now. Joseph's son Charles continued the brewery until it was sold to Flowers in 1914.

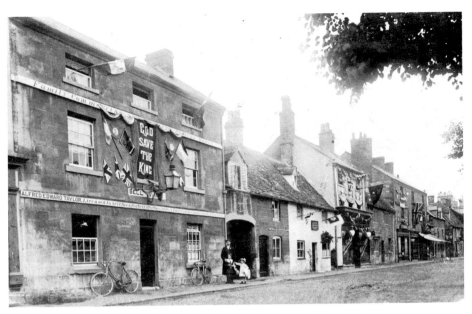

The Bell Inn, Moreton-in-Marsh, ready for the Coronation of George V. The stone frontage was added to an older building in Georgian times to gentrify the old coaching inn. In the late nineteenth century, the Bell was owned by brewer William Turner of Shipston-on-Stour. Now it serves up to six ales from the larger national brewers.

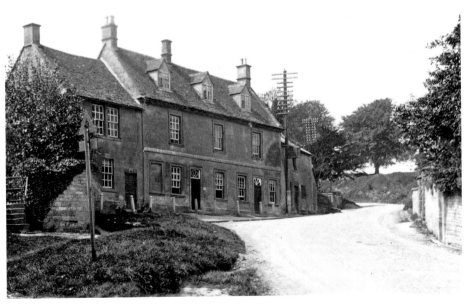

In a commanding position overlooking Bourton-on-the-Hill, the award-winning Horse & Groom has been an inn for over 150 years. Saved from closure in 2005, the inn is now an elegant establishment. The smart interior lends itself to country dining, but the Horse & Groom also makes a heartening effort to stock three ales from local craft brewers. Cheers.

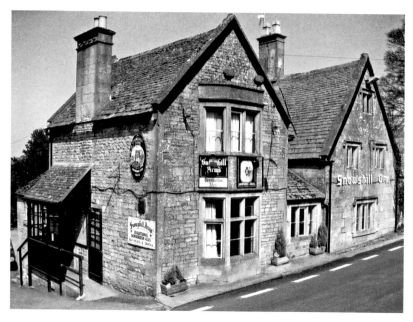

Parts of the Snowshill Arms date back to the thirteenth century, and up to the 1900s it was a home brew inn. Now it is a Donnington house. Blanche Beard began running the pub – just a parlour with no bar – in 1911. She retired in 1968 at the age of ninety-two. Nowadays, the increased demands on publicans render this feat unimaginable.

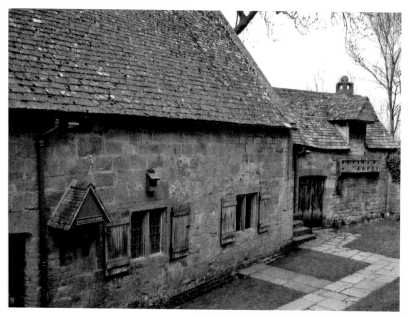

The old brewery for the Snowshill estate was located next to the Manor in the former bakehouse (now called the Priest's House). This was where noted eclectic collector Charles Wade later made his home. On the gable end, the gilded weather vane is an old German inn sign, and a large brewing pan resides near the modern toilet block.

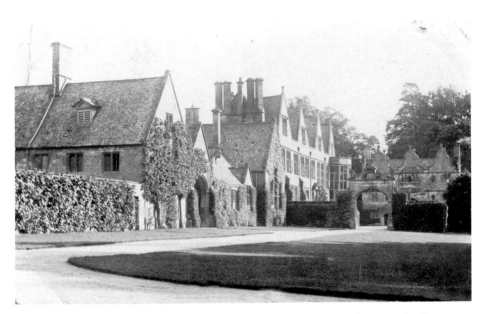

Stanway House had an old brewhouse too (left). Brewing was restarted in 1993 by Alex Pennycook. Uniquely in England, wood-fired coppers are solely used, which require fifty tons of wood per year. Stanway Brewery recently produced its one thousandth brew. Beers such as Stanney Bitter and Cotteswold Gold are sold in local pubs such as the Pheasant in Toddington.

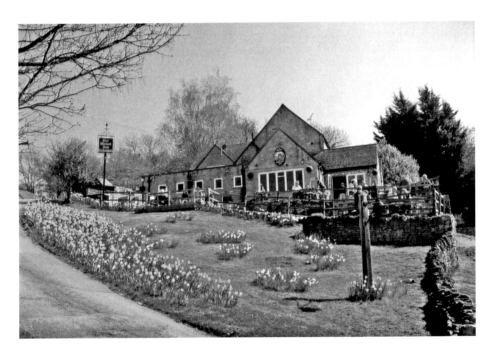

Above the unspoilt village of Stanton, the Mount Inn was once a beerhouse with an off-sales licence only. Now it is a marvellous, proper pub – and Donnington beers are served. In 2009, a mysterious druid's sign appeared by the Stanton stone circle at the bottom of the daffodil bank. Head gardener Geoff Smiles wondered if it was a 'secret message from King Arthur'.

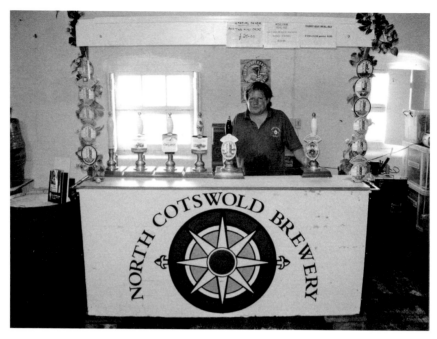

Jon Pilling acquired the North Cotswold Brewery in 2005. His sheer enthusiasm and endeavour is evident in that he brews over twenty regular, seasonal, monthly and one-off ales. These include Pig Brook Bitter, Hung Drawn 'n' Portered (SIBA 2009 Regional category winner) and Sheep Town for the Shipston-on-Stour Wool Fair. Jon has been called an 'extreme brewer,' especially apt for his tour de force Arctic Global Warmer which weighs in at 15% ABV.

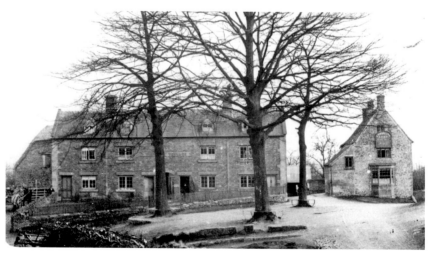

On the right, two miles from Chipping Camden, the Ebrington Arms is so good it has just won CAMRA North Cotswold Pub of the Year for the second year running. The seventeenth-century pub retains the qualities of a traditional Cotswold inn and community hub. The Ebrington arms shows a clear commitment to Cotswold ales with up to five available.

At Chipping Campden, the Volunteer Inn was CAMRA Gloucestershire Pub of the Year in 1998. It still has a great atmosphere and serves excellent beer including its own badged Volunteer Ale (from Goffs of Winchcombe). There is an Indian restaurant at the rear too. Up the road, in the 1900s, the Red Lion Inn advertised Home Brewed Ales on its inn sign.

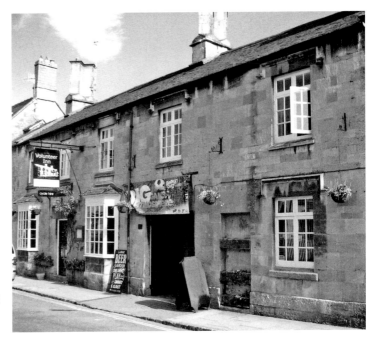

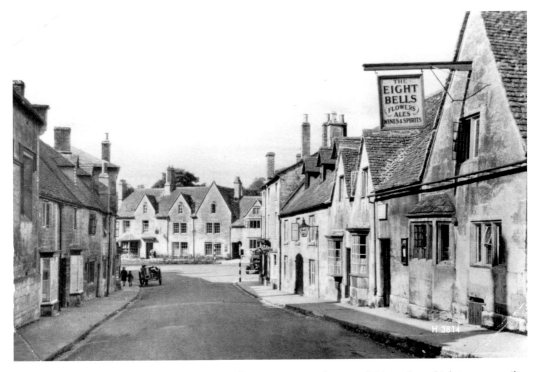

At the other end of town, the Eight Bells is an ancient characterful hostelry which is now easily identified by its inn sign bracket with ... eight bells! A changing range of four frothing Cotswold ales is served. Nearby, the annual Cotswold Olimpick Games are held at Dover's Hill. Events such as shin-kicking have captured the wider public imagination.

To the east of Broadway on Fish Hill was the individually styled Fish Inn. It claimed to be the oldest inn in England and was mentioned in the Doomsday Book of 1086. Monks supposedly kept fish there, hence its name. Once roadside, the inn closed several decades ago and is now a private house set back from the A44.

According to old guide books, Broadway once had twenty-three inns. The Coach & Horses in the Upper High Street was one of the many to close. The early twentieth century inn sign shows Harriet Harris as landlady 'Licensed to sell Beer, Porter and Cider, Wine & Spirits'. She was also a 'Dealer in Tobacco'. The inn is now a private residence.

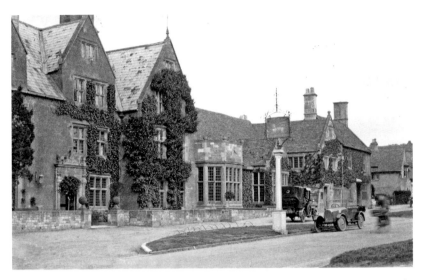

The celebrated Lygon Arms is a most magnificent hostelry and has entertained visitors since before Henry VIII. Originally the White Hart, the generous proportions today have been achieved through expansion into neighbouring properties. Early nineteenth-century inventories list a brewhouse. In 1814, the larder contained a 'beer machine and jars of pickled walnuts'. It's a bit grander than that today.

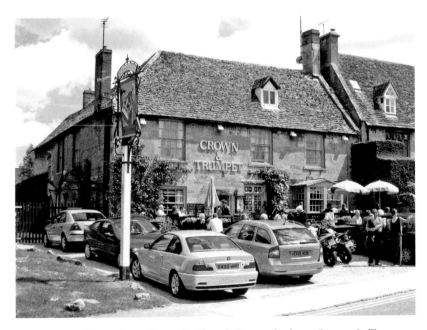

Tucked behind Broadway Green in Church Street, the busy Crown & Trumpet Inn is well worth seeking out. It is an award-winning traditional Cotswold pub with four local ales available – usually including beers from Stanway and Stroud Breweries . Memorabilia, especially from Flowers Brewery, adorns the walls and to complete the picture, Morris dancers regularly visit.

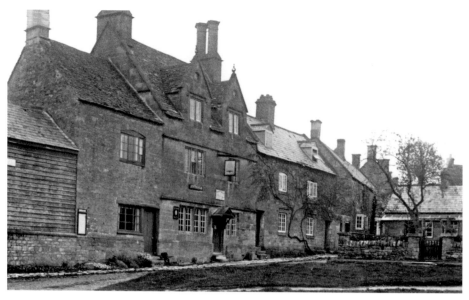

The Bell Inn at Willersey has a touch of grandeur about its dressed stone frontage. It is certainly a dignified inn, looking out onto the village green and duck pond. The comfortable interior continues the genteel feel, indicating that the Bell is more of a country dining inn. Members of the Bell Inn Golf Society are regular customers.

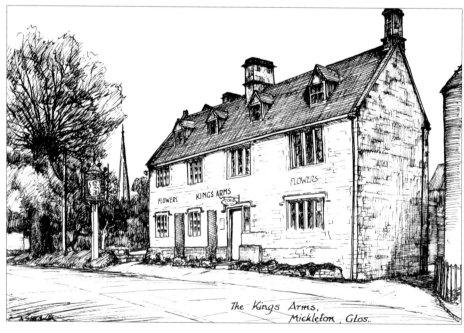

At the northern edge of the Cotswolds, the Kings Arms at Mickleton has been welcoming guests for centuries. Nearby, the Three Ways House Hotel is home to the life-enriching Pudding Club, but for those who desire something small and savoury, the home-cooked bar appetisers at the Kings Arms are possibly the best in the Cotswolds.

West Cotswolds

Down in Nettleton Bottom, the 300 year old Golden Heart Inn sits alongside the busy A417 near Brimpsfield. With all the traditional attributes of a welcoming Cotswold hostelry, the multi-roomed Golden Heart scooped Pub of the Year 2009 in *The Good Pub Guide*. Four frequently changing ales are served with the local Festival Brewery usually represented.

Until the mid nineteenth century, the Royal George Hotel (then George Inn) at Birdlip was a homebrew inn with J. Fewings brewing back then. Now it is owned by Old English Inns, part of Greene King. After the advent of the motor car, the hotel claimed it had the 'Largest Garage in the West.' Now it advertises its excellent conference facilities.

Most people are familiar with the Air Balloon roundabout near Birdlip via traffic reports on national radio. The 200 year old frontage of the Air Balloon Inn overlooks its own traffic island. A brewhouse to the rear, latterly used by Richard Tuffly, provided the inn with beer during the nineteenth century. Today, Greene King supplies a good selection of four ales.

In 1974 the unassuming New Inn at Shurdington changed its name to The Cheese Rollers, and became forever associated with the madcap event that happens annually at nearby Coopers Hill. In 2010 the official event was cancelled and the first 'unofficial organised' event took place. The cheese looked suspiciously like, ahem, a small French Brie, not the usual 7 lb Double Gloucester.

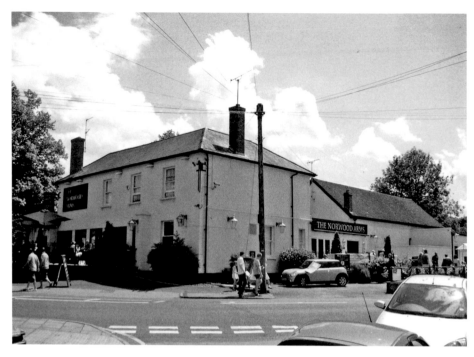

At Leckhampton, two brew-pubs survived into the twentieth century. Harry Warner brewed behind the Norwood Arms (pictured) until around 1910. He was also associated with the Grosvenor Brewery in Albion Street, Cheltenham, in Edwardian times. James Kitching is known to have brewed at the Exmouth Arms from the late 1880s until the early 1920s. Both pubs are still trading.

George Combe (born 1815) of the Brockhampton Brewery had two sons who later became brewers. When George died in 1871, Thomas Combe continued at Brockhampton, while Benjamin (born 1845) acquired the Grafton Brewery in Leckhampton around this time. The Grafton Brewery, established by Ashby Saunders in the 1850s was subsequently merged with the old Nailsworth Brewery in 1899.

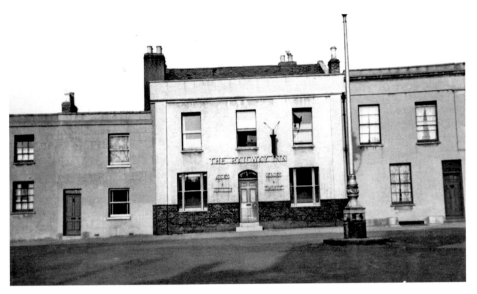

From 1836 the Railway Inn in Norwood Triangle, Leckhampton, served quarrymen and workers from the horse-drawn tramway that ran in front of the pub. By the time the rails were taken up in 1861, the pub continued to serve the artisan township that had developed as a result of the tramway. The Railway Inn unfortunately closed a century later in 1968.

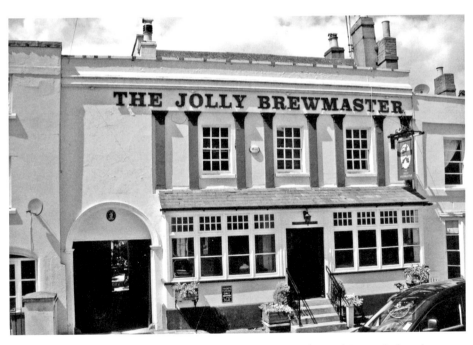

The CAMRA award-winning Jolly Brewmaster in Painswick Road is a real ale pub par excellence. With an ever-changing range, the 'Jolly Brew' has been at the forefront of the renaissance of cask beers, especially from local breweries. In a previous incarnation as the British Union Inn (the name changed in 1961) J. Gardner brewed at the pub back in the mid nineteenth century.

In Horsefair Street, Charlton Kings, the handsome Royal Hotel has recently been tastefully modernised and is now The Royal. It is a popular venue which serves three ales. Nearby, where Croft Court now stands, there was a small brewery. Details about the Charlton Kings Brewery are sketchy, but the partnership of Wire & Burney were trading there in the 1890s.

The London Inn was one of several home brew-pubs around Charlton Kings in the mid to late nineteenth century. William Melvin brewed there in the 1850s as did James Clifford at the Beaufort Arms (just into Cheltenham). Later on, in the 1880s, Henry Clarke brewed at the Duke of York. Today a pub stroll around Charlton Kings is just as rewarding.

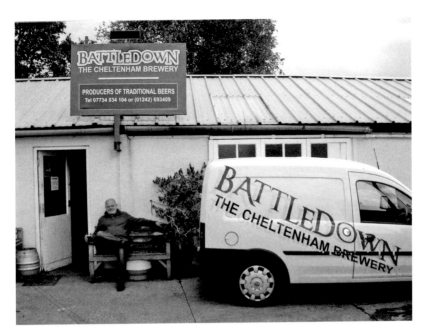

Roland Elliott-Berry takes a quick break outside the Battledown Brewery he set up in 2005. Cheltenham had been without a brewery since Whitbread Flowers closed in 1998. Anticipation grew as the launch date approached. Beers such as Saxon and the darker Turncoat quickly established Battledown's reputation for brewing distinctive ales. Cheltenham was on the brewing map again.

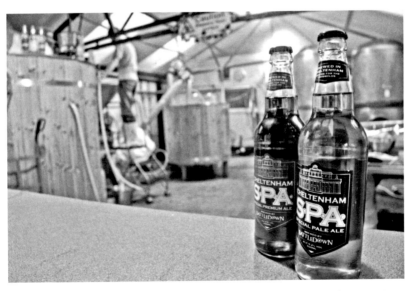

With brewer Ben Jennison-Phillips on board, sales have continued to rise. Beer quality is consistently high as demonstrated by two recent SIBA awards. At the Battledown 5th Anniversary Festival at the Varsity in Cheltenham, every one of their seven ales (including Sunbeam and Four Kings) was on top form and truly representative of its beer style. (Photograph by Charles Taylor)

To help publicise Cheltenham Flyer Ale which celebrated the GWR 150, Whitbread Flowers Brewery laid on a treat for some of their licensees. On Tuesday 10 September 1985, they were taken by coach to Newport and returned in style on a Pullman train pulled by the *Clun Castle* locomotive. Cheltenham Flyer Ale was the beer of the day.

SAVOUR THE FINEST ALES FROM THE PRESCOTT BREWERY

PRESCOTT
BREWERY
WWW.PRESCOTTALES.CO.UK

Prescott Brewery, the most recent microbrewery in Cheltenham, was established in 2009. With eye-catching point of sale material, depicting the motor racing heritage of the Prescott Hill Climb track, their ales such as Track Record and Grand Prix have become widely available in Cotswold pubs. New Head Brewer James Bubb ensures Prescott's 'Great British Lubricants' are staying out in front.

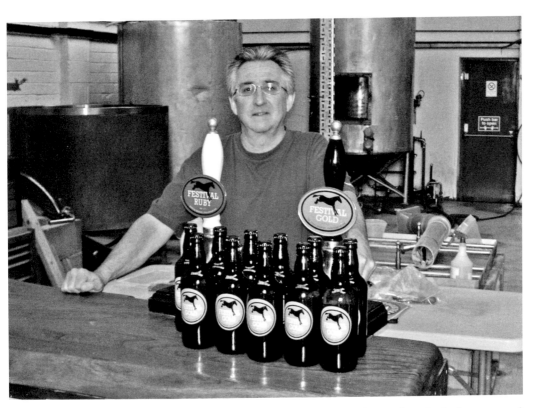

Andy Forbes set up the Festival Brewery during 2007 in Cheltenham, where festivals are part of the landscape. The brewery has now established itself in the competitive Cotswold market with an identity clearly inspired by Cheltenham's famous Horse Racing Festival. Ales such as Festival Gold and Festival Ruby have become winners as the brewery goes from strength to strength.

Behind the church at Prestbury, in Mill Street, is the wonderful Plough Inn. The thatched, half-timbered inn is a real find – with two small serving counters, ales dispensed from the casks and small traditional rooms. The welcome is just right; the beers bang on. This type of pub is becoming scarcer and scarcer and is so worth visiting.

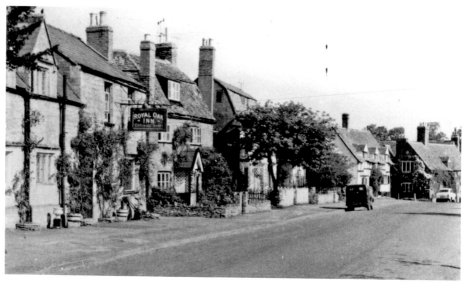

Prestbury is home to another super hostelry, The Royal Oak in The Burgage. Behind the original etched windows, Timothy Taylor Landlord and two well chosen guest ales await. Beer and cider festivals are held annually. Also in The Burgage until 1859 was the Grotto. It brewed its own ale and was a house of ill-repute. Shame it closed.

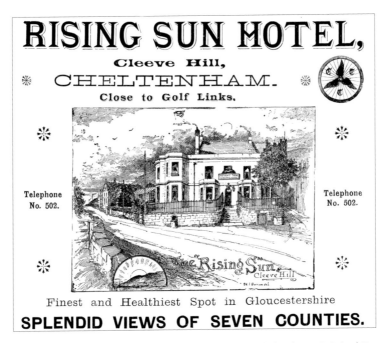

RISING SUN HOTEL,
Cleeve Hill,
CHELTENHAM.
Close to Golf Links.

Telephone No. 502.

Telephone No. 502.

Finest and Healthiest Spot in Gloucestershire
SPLENDID VIEWS OF SEVEN COUNTIES.

At the time of this 1903 advert, James Phillips dispensed Cheltenham Original Brewery ales at the Rising Sun. He also provided 'Luncheons, Dinners and Teas on the Shortest Notice'. Trams from both stations in Cheltenham ran past the door. Fifty years previously, I. Simmons had brewed beer behind the hotel. Now, four Greene King ales are served.

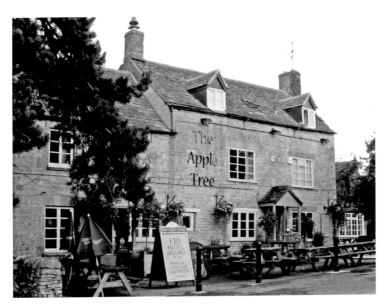

On the western slopes of Cleeve Hill, the Apple Tree Inn at Woodmancote has to be one of Greene King's best pubs in the Cotswolds. Formerly a cider house, the Apple Tree has been modernised but partitioned to provide a traditional atmosphere. Beer quality is high and along with three regular ales, a monthly 'guest ale menu' is promoted.

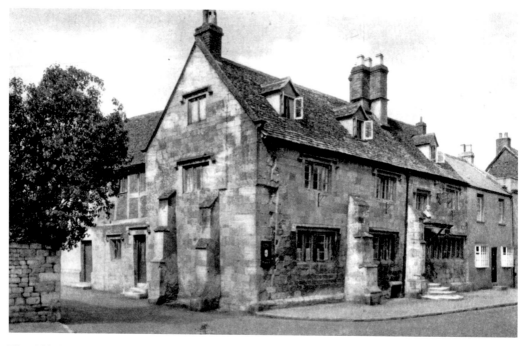

The Old Corner Cupboard Inn at Winchcombe is perhaps 500-600 years old. The fabulous buttressed structure was once a farmhouse and possibly had ecclesiastical connections. An old brewhouse is now part of the restaurant to the rear. The Corner Cupboard is one of six pubs in Winchcombe, each with its own style, making the town well worth a visit.

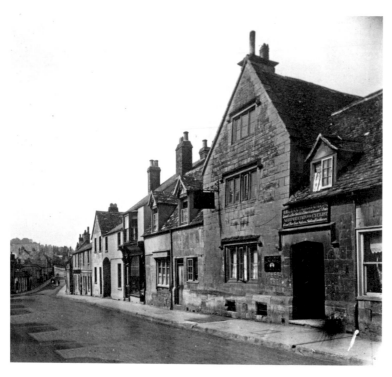

The Old White Lion in North Street is a characterful fifteenth century coaching inn with its traditional bar on the right. At the end of the terrace was the North Street Brewery. Built around 1840, it was acquired by the Nailsworth Brewery by the 1890s. The current owners found old bottling equipment, suggesting that ale was transported in casks and bottled at Winchcombe.

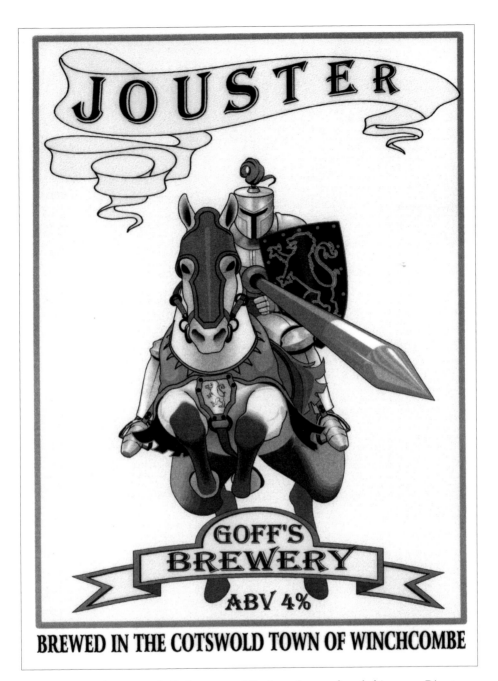

JOUSTER

GOFF'S
BREWERY
ABV 4%

BREWED IN THE COTSWOLD TOWN OF WINCHCOMBE

The multi award-winning Goffs Brewery at Winchcombe was founded in 1994. Disaster struck in 2007 when the brewery was flooded by the River Isbourne. Owner Marcus Goff and Head Brewer Nick Cooper set about repairing the damage. A few months later, regular beers such as White Knight and Tournament, along with the seasonal Ales of the Round Table were cheered back.

"The Oldest established licensed house in the Village"
The Star Inn. Ashton - under - Hill, Glos.
Accommodation for Cyclists. Luncheons & Teas Provided.
Ales, Stouts & Cigars of the best quality.
Within five minutes walk of The Midland Railway Station.
Good Stabling. Walter Cresswell Proprietor.

The Star Inn at Ashton under Hill peeps out from behind two trees, which have now been replaced by a palm. The Star is the only survivor of three inns recorded in 1900 (the White Hart and Plough & Harrow both closed). Three traditional ales are served and all pork recipes are supplied from the family farm nearby.

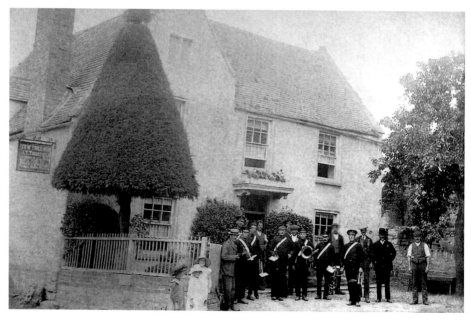

Believed to date from the seventeenth century and still retaining many period features, the Yew Tree Inn at Conderton is a multi-roomed rural gem now owned by Wadworth. In the twentieth century the licence passed through three generations of the Turbefield family who would open up at 6 a.m. to serve farm workers with bread and cheese and flagons of cider produced at the pub.

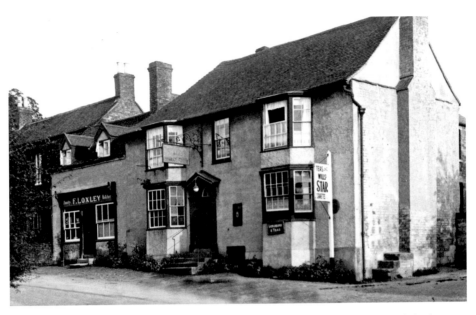

Two curious rocks on Bredon Hill are called the King and Queen Stones. Until the late nineteenth century a Manorial Court was proclaimed at the stones and adjourned to the Royal Oak Inn at Bredon. Today the Royal Oak is a comfortable, friendly community pub. Bredon's other pub, the Fox & Hounds, with fox murals and tiled replica is well worth visiting too.

On the left is the Old Cider House in Bredon. Until the early 1920s cider and perry were sold through a hatch in the front door for one penny a quart or three nips (cowhorn cups) for a farthing. The thick greenish cider stuck to the sides of the cups. Jim Skinner, the last cider maker, always dipped a rat into the vat. Only the tail and footpads didn't dissolve.

After the closure of the Plough Inn, Mill Inn and Queen Elizabeth (formerly Queens Head Inn), Elmley Castle was left with no pub. Thankfully, The Queen Elizabeth was reopened in 2009 and is in the process of major restoration – there were seven layers of carpet in the bar. The pub welcomes locals and visitors with its own badged Elmley Queen ale.

At Eckington, the Anchor Inn is a very popular pub. Two traditional ales, Bass and Pedigree, along with two guest ales are served. The Jones family ran the pub for eighty years until 1940. Next landlord Albert Smith could not keep up with the Joneses due to the shortage of beer in the war, so made cider which he called Tanglefoot.

By Eckington Church, the Crown Brewery was directly behind the old Crown Inn. The delivery drays used the passageway to the left of the pub. Established around the mid-nineteenth century, the brewery had closed by the start of the First World War, during which it was used as a jam factory. The brewery buildings are extant, partly converted into a house.

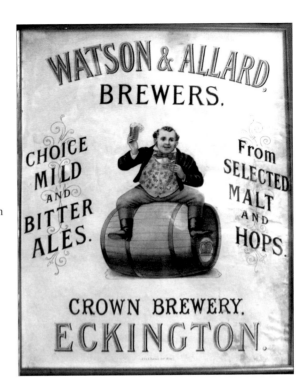

The 300 year old Crown Inn was supplied with Crown Ales. Then it was tied to Hunt Edmunds and finally to M&B. Sadly the pub closed in 1993 after yellow no-parking lines arrived in Eckington and trade declined. It seems a shame to end with a pub and brewery that have both closed. The message has to be: VISIT YOUR LOCAL.

ALSO AVAILABLE FROM
AMBERLEY PUBLISHING

DORSET PUBS
AND BREWERIES

Tim Edgell

Price: £12.99
ISBN: 978-1-84868-203-0
Binding: PB
Extent: 128 pages

AVAILABLE FROM ALL GOOD BOOKSHOPS OR ORDER DIRECT
FROM OUR WEBSITE WWW.AMBERLEYBOOKS.COM